PAINTING WATERCOLORS FROM PHOTOGRAPHS

BY GEORG SHOOK AND GARY WITT

PAINTING WATERCOLORS FROM PHOTOGRAPHS

BY GEORG SHOOK AND GARY WITT

WATSON-GUPTILL PUBLICATIONS/NEW YORK

To Mother and Daddy who helped me to recognize and appreciate the beauty in simple things. And to Lorna Jean and Jon.

Gift – 9/86

First published 1983 in New York by Watson-Guptill Publications,
a division of Billboard Publications, Inc.,
1515 Broadway, New York, N.Y. 10036

Library of Congress Cataloging in Publication Data
Shook, Georg, 1934–
 Painting watercolors from photographs.
 Includes index.
 1. Water-color painting—Technique. 2. Painting from
photographs. I. Witt, Gary, 1945– . II. Title.
ND2422.S53 1983 751.42'2 82-23803
ISBN 0-8230-3873-4

Distributed in the United Kingdom by Phaidon Press Ltd., Littlegate
House, St. Ebbe's St., Oxford

Manufactured in Japan

1 2 3 4 5 6 7 8 9/88 87 86 85 84 83

Preface

Art, to me, is a bridge of communication through which I make my statement about the world around me. It is these "things around me" that serve as inspirations for my paintings, which record not only an object, event, face, or moment in time, but also my reaction or emotional response to these things. I am first and foremost a watercolor painter—and a realist at that—who likes to accept the challenge of depicting familiar or commonplace objects in a special way that captures the effects of light and shadow, form, and space, to evoke feelings that were generated in me by the original subjects. In short, I like to take something commonplace and transform it into an interesting painting. And my paintings, then, become a counterpoint between the transitory and the timeless.

To accomplish these goals in painting, I will often use a camera as a tool. However, I am eager to point out that the images captured by the camera are seldom viewed by me as total compositions, but rather as supporting documentation. The camera is for me an information-gathering instrument, my space-age sketchbook. I use photographs for the information they give me about light and shadows or architectural detail, but invariably, I will add elements of my personal emotional response to any image created. And it is this artistic sovereignty that separates art from photography and separates creative paintings from copied photographs.

Georg Shook

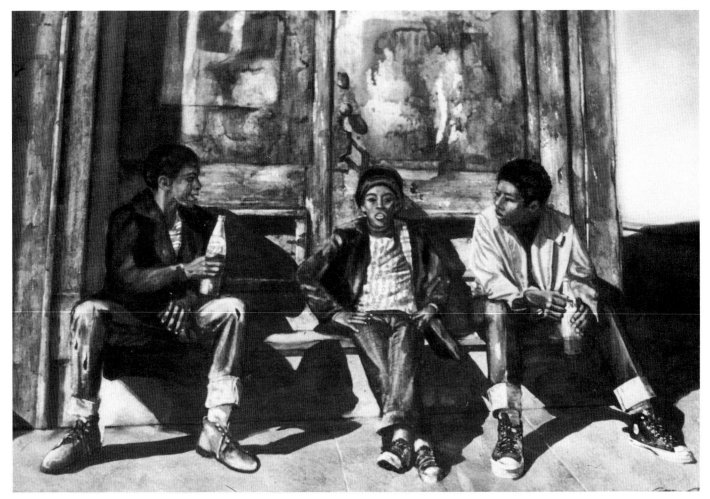

"LEROY, WILLIE JOE AND FRIEND"

Contents

Acknowledgments

I am grateful to those who helped make this book possible, especially:

Margaret Witt, who assisted with her time, energy, and support.

Dorothy Spencer, David Lewis, and Bonnie Silverstein of Watson-Guptill Publications for their advice, patience, and moral support.

All those persons who own paintings reproduced in this book.

David Pottenger of the Strathmore Paper Company who first introduced me to the Strathmore Hi-Plate surface.

Gary Witt, who went beyond the call of duty by writing, editing, typing, and offering constant encouragement.

Jay Anning, whose creative flair for design has added so much to the overall look of this book.

Introduction

Artists have been using photography for years. In fact, Aristotle wrote notations on the principle of the camera obscura over 2000 years ago. However, it wasn't until the early 1500s that (according to Vasari) artists began using the camera obscura as a "drawing instrument," to project an image of a real object onto a sheet of paper. Such master painters as Vermeer and Canaletto were among those known to have used it.

With the introduction of the camera in the early 1800s, the use of photography by artists became more widespread, particularly in the beginning stages of photography. European masters such as Cézanne, Delacroix, Degas, and Gauguin worked from photographs, as did the Americans Eakins, Hopper, Homer, and Burchfield. And today, most artists admit to using at least some photography for reference, though most qualify its use.

Despite the camera's superior ability to record data, the great artists used cameras not to duplicate the images they saw, but for reference, just as they would have used the real subject. Also, because they often worked from someone else's photographs, there was an even greater reason not to copy another's composition. With the exception of the photorealists, artists rarely try to make their paintings appear like photographs—but this is not the issue. Creating the appearance of reality has little to do with whether the subject was viewed directly or from a photograph.

Besides its ability to record a scene, the camera is useful because of its speed. Most artists have a limited amount of time in which to record information, and photography provides a means of gaining many impressions of a subject in much less time than it would take to make sketches.

Also, through photography, an artist can stop time. A photo can halt a shadow traversing a structure, stop a river from flowing, or capture the movement of a bird in flight. In short, the photograph can "hold" for observation any reference needed to complete a painting. And this ability to record a moment in time is, without a doubt, its most fantastic quality.

I hope this book will help you to realize and take advantage of the many benefits photography has to offer the artist.

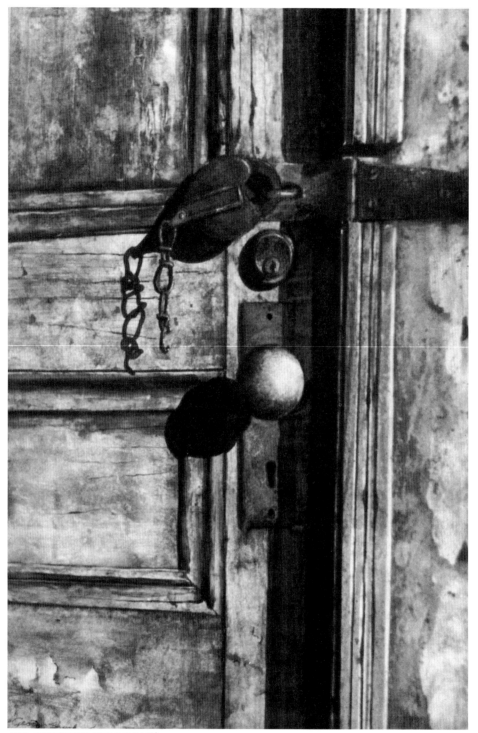

"SWEETHEART LOCK"

MATERIALS
AND EQUIPMENT

Painting Materials

When it comes to equipment, my philosophy is very simple: buy good painting equipment and care for it well. Not only do the best brushes, paints, paper, and other materials last longer, but they also give the best results. And if a piece of equipment proves hard to locate, create it! Use your imagination and experiment to come up with something that will do the job as well as the original.

You may have your own favorite materials—and by all means continue to use them. But for those of you who are wondering what I use, here is a summary. More detailed information can be found in my book, *Sharp Focus Watercolor Painting*.

Drawing Board. I do most of my painting at a large Dietzgen hydraulic drawing board, 48″ x 60″ (122 x 152 cm). The easel height can be adjusted, and the board can be turned or tilted to any angle to reach a particular area of a painting.

Paper. There are several hot-pressed papers on the market. Many brands are excellent, including the Strathmore 115 series, the Gemini series, and the Strathmore Hi-Plate illustration board, but I prefer this last one because it has the smoothest surface of all. In fact, all of my paintings are done on the Strathmore Hi-Plate illustration board, a hot-pressed surface usually used for commercial art, because its surface is so smooth and non-absorbent that the paint lies right on top, giving a brilliant and intense effect to my colors and letting me create textures by manipulating and controlling the pigment.

Strathmore Hi-Plate illustration board comes in two weights and sizes: 4-ply and 14-ply thickness, and 20″ x 30″ (51 x 76 cm) and 30″ x 40″ (76 x 102 cm) large. My boards are stored flat in a Dietzgen wooden storage cabinet (pictured). I also store my finished paintings here before framing and shipping them.

Brushes. I try to limit myself to as few brushes as possible for my work on hot-pressed surfaces. I generally use three types: 1) Pointed sables—round brushes, that are excellent for detail work, especially with thinner pigments. 2) Chiseled wash brushes, which I use most often because they are versatile—they can be used for anything from broad strokes to the finest detail merely by adjusting the angle of the brushstroke. 3) Stiff bristle brushes, good for creating textures and for surface color mixing.

Brush Box. Since I travel to so many workshops, I use this box to carry my brushes without damaging them. It holds a complete set of brushes, as well as erasers, pencils, razor blades, and other small items. It folds to close, and the springs hold the brushes securely. The box has proven handy for both indoor and outdoor use.

Paints. Although I have fifteen colors in my palette, I usually use only three to five colors, or combinations of them, in any one painting. I tend to favor the earth colors, since they are so appropriate for landscapes. (My favorite brands are Winsor & Newton and Le Franc & Bourgeois pigments.) I prefer tubed paint to cakes because it is more soluble and adheres better to the hot-pressed surface.

Palette. I use a John Pike plastic watercolor palette. It has 20 compartments set around a smooth center area and a snap-on lid. I find the unit so handy that I use it in the studio as well as outdoors.

Colors. I arrange my paints as follows (clockwise around from lower left): raw sienna, raw umber, burnt umber, brown madder, burnt sienna, olive green (two wells), mauve, gamboge, cadmium yellow, cadmium red, scarlet, Winsor red, Van Dyke brown (two wells), Prussian blue, ultramarine, cerulean blue, Winsor (Hortensia) blue, Davy's gray.

Sponges. I use sponges frequently for dripping, dabbing, or lifting paint to create various textures and patterns. I prefer synthetic sponges because they last longer, have more "bounce," and come in a greater variety of textures and patterns.

Water Containers. A good water container is important. I never seemed able to find a suitable one, so I improvised. For indoor use, I designed and had a potter friend create three different-sized cups for water to moisten or rinse my brushes. My outdoor water container is a surplus 30-caliber ammunition box with a wire screen folded to fit about two inches (5 cm) below the water line. It holds my brushes and doubles as a scrubbing area for cleaning them.

Photographic Equipment

As I have said earlier, I regard the camera as a tool for the artist, a means to an end, for a space-age sketchbook. Like everything else you do, it pays to do photography well, and this requires practice and some experimentation. But before long, you'll see just how versatile a tool photography can be.

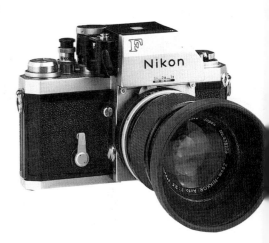

Cameras. There is a bewildering variety of cameras on the market today, and basically anything that will take a decent picture will serve your purposes. However, although the 110 Instamatics and the new Disc cameras are good, I feel that they limit your creativity: their negative size is too small to show much detail, you cannot interchange lenses, and everything is so automatic that you can't control the way the picture will look. As for the Polaroid instant cameras, their image quality is fair, and the cost of film is very high.

Therefore, I prefer to use a 35mm single-lens reflex (SLR) camera. The 35mm format yields a bigger negative so you can count on your prints or slides having great detail. And the SLR allows you to interchange lenses where the rangefinder often does not. Changing lenses is almost a necessity for the artist who wants to take various types of photographs, from wide-angle shots to close-ups, of his subject.

Also, with this type of equipment, you can meter the light and set the camera yourself. This allows for more creative results than the automatic cameras, which give an average, often less dramatic rendition of the scene. I use a Nikon Photomic FTN camera, but all the major 35mm SLR brands today are good.

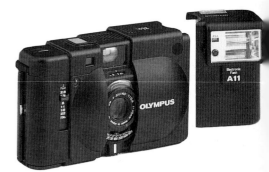

Lenses. As I have mentioned, one of the greatest advantages of the single-lens reflex camera is that it will take different types of lenses. Lenses are identified by their focal length, and the larger the number, the narrower the angle of view. Hence, the wide-angle lenses have small numbers—18mm, 24mm, 28mm, while the "normal" lenses run from about 43mm to 60mm. Telephoto lenses start at around 80mm, and while 135mm is a standard size, telephoto lenses can range up to 600 or even 1200mm. Thus, the larger the number of the lens, the narrower the angle of view and the closer the subject appears.

My favorite lens is the versatile 43–86mm zoom lens. I use it more often than any of the others. Set at 43mm, it gives me a slightly wider angle than the normal 50mm lens if I need it, and the 86mm setting closes in on a scene without my having to walk to it. I also have an 85–205mm zoom lens, which brings distant subjects really close. Furthermore, I can extend the versatility of these lenses by using a 2X extender. This doubles the focal length of my telephoto lenses, bringing a subject twice as close. I also use a 50mm, *f*/1.4 lens for low-light use, a 50mm micro lens for close-ups and capturing details in finished paintings, and a 28mm wide-angle lens for capturing wide fields of view such as landscapes.

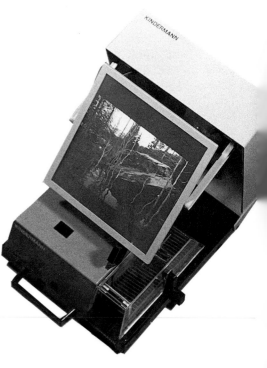

Other Cameras. I use another, smaller camera sometimes when I have to fly to workshops and need to travel light. It is an Olympus XA, a versatile 35mm rangefinder camera with a single, fixed lens. This little camera is so light and handy that I can carry it everywhere in my pocket, and it takes a nice full-frame picture or slide. It also has a little detachable flash unit. (I also have a flash unit for my SLR, a fan-type reflector bulb unit, but the newer electronic flash units are much more convenient and quite inexpensive.) However, I seldom use a flash—if I'm indoors, I set up lights.

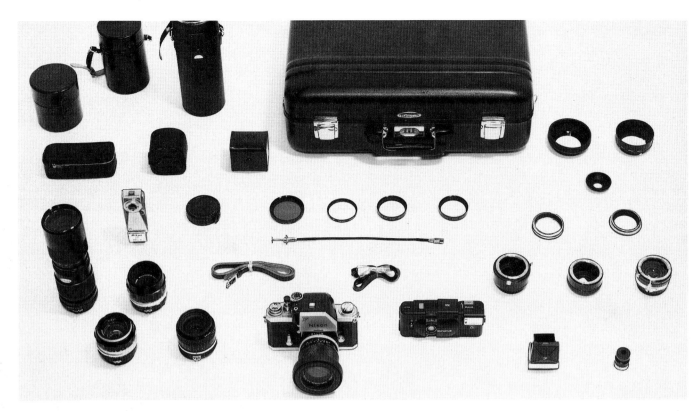

Filters. I use a variety of filters, especially an A1 skylight filter for cutting out glare and just protecting the lens from being scratched or damaged. Many people leave a skylight filter on their lens all of the time for just this reason. I also have a polarizing filter to darken skies and increase contrast, but I also use mine to get rid of glare and reflections in glass, chrome, or water. Sometimes I also use red, blue, yellow, or orange filters. Each enhances the photograph in a different way, such as by darkening the sky or by lightening the grass and foliage. But these filters are only for black-and-white film, not color.

Film. Two of the most commonly used slide films are Kodachrome 25 and 64. I find that ISO (ASA) 64 is a better film for me, since its slightly faster speed allows me to work in lower light situations than the ISO 25. I also use Ektachrome 64 for my slides occasionally, since it can be more quickly developed by a local lab. For color prints, I use Kodachrome II (ISO 100) or a high-speed ISO 200 or 400 film if I expect to be taking pictures in very low-light situations.

When I am shooting indoors, I use Ektachrome 50, a tungsten-balanced film for use with incandescent lighting. I often use this film with 3200 K, 500 watt floodlights to photograph my paintings for museums or competitions. I photograph these paintings outdoors when it's not convenient to do otherwise. Then I try to shoot them in a light shade, never in the direct sunlight, which will wash out the color and detail in the photograph.

Slide Viewers. For viewing my slides, I have two slide viewers. One is a Sawyer (right). It has a 3½″ (9cm) square screen, holds 20 slides, and uses a fan-cooled lamp. However, one of its drawbacks is that it will damage the slide, or even the table it is resting on, if left running too long.

My favorite viewer is a Kindermann (left). It has a fan-cooled lamp and a screen size of 8″ (20cm) square. It is excellent for viewing slides for an extended time, and the clarity of its image is superb. This unit also doubles as a projector if the image needs to be enlarged even more.

15

Using Lenses of Different Focal Lengths

I took these photographs from the same spot on Riverside Drive in Memphis. Notice that the widest angle of view (28mm) throws the subject back further than it actually is, and shows some optical distortion; the more "normal" lenses approximate what is ordinarily seen by the human eye; and the telephoto lenses narrow the scene but bring the subjects in closer. Telephoto lenses enable one to get "closer" to the subject without actually having to change locations. I especially like my 43–86mm zoom lens. A zoom lens is a variable focal length lens, meaning that the focal length can be changed by simply twisting the barrel of the lens or pushing it in and out. The zoom lens allows the photographer to enjoy the variety of several focal lengths without having to actually change lenses on the camera.

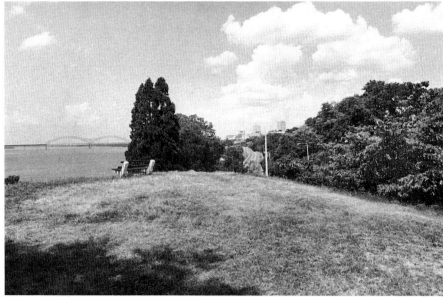

28MM LENS

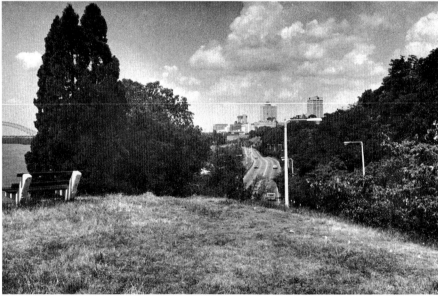

43-86MM ZOOM LENS AT 43MM

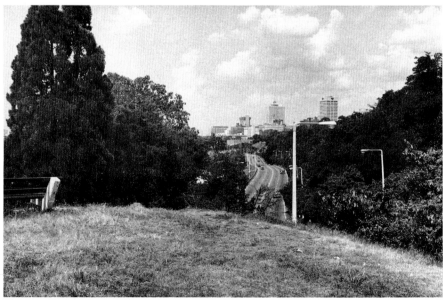

50 MM (NORMAL) LENS

ZOOM LENS AT 86MM

85-205MM ZOOM LENS AT 205MM

410 MM (205MM LENS WITH A 2x EXTENDER)

"COUNTRY LANE"

GATHERING
REFERENCE MATERIAL

A Typical Field Trip

Several times a year I embark on field trips—photo-gathering expeditions to collect reference material. These jaunts help replenish my slide library with images I may later want to incorporate into paintings. They also give me the opportunity to recharge my creative batteries, so to speak, since I derive my inspiration from the beautiful and interesting scenery that exists in such abundance in the Delta area of the South.

I seem to be so busy these days, that I seldom have the luxury of stopping and making sketches of a particular scene. So I take advantage of the little time I have to gather information through photography. For me, then, the camera is a space-age sketchbook. I can take literally dozens of photographs in the same time it would take me to do one sketch. And photographs can really contain more information—for example, about light, color, texture, and density—than any single sketch.

Bear in mind, however, that I am not looking for a single scene that would make a nice painting. Rather, I am gathering information, collecting various visual elements that can be used in combination with other elements to create a satisfying painting. For instance, I might use a cottage or structure from one photograph, then add a tree from another, and a bridge from another, then add a riverbank which is only roughly derived from yet another photograph. I would then put these elements together, guided by my artistic instincts, and hopefully produce a painting that reflects my emotional state of mind. I definitely do not shoot any photograph with the idea that I will later do an exact sketch of it or translate it into an exact painting. I just look at these reference photos as bits and pieces of information that I might later combine into significant images.

Camera and Film. For this particular trip I loaded my Nikon F2 with Ektachrome 64, since there was plenty of sunlight. Depending upon the lighting conditions, I might also use Kodachrome 200 or 400 ISO, or if I expect to be in low-light situations, I may even select a faster black-and-white film. Color slides are often not true to the actual colors of the scene anyway, so I generally use them only as a guide to the color range of the subject. And since I often change my color palette anyway, I may sometimes shoot my reference photos in black and white, using Plus X (ISO 125) or a faster film like Tri-X (ISO 400) which I can "push" to ISO 800 for really low-light shooting. The important thing to realize is that film is cheap, and I know that I may never return to the scene again. So I take hundreds of photographs during a field trip. I can always cull out the poor ones later.

Lenses. My choice of lenses varies depending on the requirements of the particular scene. My most versatile lenses are the 28mm wide angle and the 43–86 zoom. I often use the 28mm wide angle to do an "establishing" shot, which takes in the surrounding area as well as the specific subject that I am photographing. Then I switch to the 43–86 zoom to get several differing focal length shots without changing lenses. On this particular field trip I used these two lenses almost exclusively.

Lighting. Like most artists, I pay close attention to lighting conditions at all times. Since I use light as a design element in my paintings, I enjoy photographing subjects under different lighting conditions. And since I like strong shadows, I try to avoid making these field trips on overcast days. On this trip I enjoyed excellent, strong lighting, and so many of my photos have shadows as part of their design.

When putting together a sketch or painting, however, I often combine elements from different photos that may have different lighting conditions. In these cases, I will make a sketch of the scene in my studio, then try to imagine the direction of the light. Having observed lighting conditions for so long, I now generally know the direction a shadow will fall if struck by sunlight at a certain angle. In fact, I often create my own direction and source of light in a painting, imagining the location and density of light and the shadow it produces. This allows me to create the mood I feel is most appropriate to the scene. However, I do like to start with a well-lighted photograph when doing my various sketches or preliminary drawings.

Speaking of light, I have often found metering light with my built-in camera meter to be a tricky business, so I have learned to bracket every shot. Generally speaking, I always try to get a meter reading of the precise subject I am interested in painting, while ignoring light from the rest of the scene that might contribute to a false reading. After setting the camera based on this "spot" reading and shooting one picture, I bracket by taking another photo at one f-stop above the reading, then dropping down and taking another shot at one f-stop below the reading. This opening and closing down of the aperture insures that one of the three pictures will be properly exposed. Incidentally, I always carry a tripod in case I stay in the field late and find myself wanting to take a low-light evening shot. I can only hand-hold the big Nikon down to 1/60 second and still get a sharp picture, but with a tripod I can get as long an exposure as I need. This is especially helpful when I need good depth of field and consequently have to stop the aperture way down. This stopping down, of course, means that a much slower shutter speed will be required.

Finding a Subject. Once my equipment is in order, I love to set out in search of interesting material. It is exciting to see a promising scene beside the road, park the car, get out, and literally stalk the area for the best material. Of course, I get the owner's permission whenever possible.

I like to look for material that exists on several levels—the functional, historical, symbolic, poetic, and the abstract—but as an artist I always have the design elements uppermost in my mind. I might lie on my stomach or climb a tree to get the best view of the design, shape, and texture of my subject. I don't try to compose the elements in the photograph too carefully, but just gather as much information as I can to take back to the studio for later use. Most of all, I try to be open to what I see and let the subject speak for itself. There are times when I will be walking around looking at one thing, when I suddenly notice another— perhaps a close-up image such as a door hinge, a bottle in a window, or the texture of weathered wood. The important thing is to see the world with fresh eyes.

I generally end my field trips when the light starts falling off and I can no longer get a good photograph. This particular trip was cut somewhat short by rain, and I returned home with something under 100 pictures.

Sorting and Cataloging. Once I am back in the studio with my developed slides, the difficult work begins. The variety of a day's shooting is vast in ways that are never apparent on the field trip itself. The camera is not like the human eye, and things look different on film. Therefore, it takes creative effort to reflect your personal and artistic point of view in these images. I usually begin by throwing out about half of the photographs I take, either because of technical shortcomings or because they are simply not interesting enough. This was the case on the field trip I am describing here, though I preserved fifty slides as being useful for a variety of reasons.

I then cataloged these slides into my reference collection, which I have

broken down into broad categories such as "structures," "trees," "still lifes," etc. These categories are further broken down into sub-categories such as: "structures: houses, barns, cityscapes, other structures"; "trees: winter, spring, fall, or summer," then perhaps a further division as to type, such as "evergreen." Still lifes can be broken into groups such as "flowers," "windows," "close-ups," and "tabletop scenes." Therefore, when I begin a painting and need information about a given subject, I will usually have this readily available.

Fortunately I keep these slides a while, for often my response to a slide changes over a period of time. Sometimes I return to an image months or even years later, and it still evokes my emotional response and memory of the subject, allowing me to base a new painting on that information. On the other hand, some slides that used to to excite me no longer hold my interest, while others that seemed dull and uninteresting might later snap me to attention as I peruse my slide files. This always reminds me of the advantages of taking as many pictures as I can, every chance I get.

But again, this process of picture-taking should be free and unstructured. I never think of how one slide might combine with another until the very final stages of the editing process back in the studio. Elements that go together naturally present themselves, and you will probably find that you have composed better and more satisfying images by ignoring your motives. Just enjoy photographing your surroundings with a fresh set of eyes. Then you will naturally be led to a variety of subjects, a variety of lighting conditions, and a variety of points of view. They will all come together as paintings when the time is right.

I LIKE THE TREE PATTERNS, AND THE WAY THE ROAD CURVES INTO THE ROLLING HILL. AS WITH THE WOODEN BLOCKS IN THE 2ND PHOTO, THESE ARE ELEMENTS I CAN USE IN FUTURE PAINTINGS.

THE PERSPECTIVE OF THE CONVERGING TREES IS INTERESTING —
I WILL PROBABLY USE THE OLD FARM IMPLEMENT IN ANOTHER SCENE

I LOOK FOR COLOR AND TEXTURE - FOR
EXAMPLE, THE DILAPIDATED FARM BUILDING
HAS A LITTLE SLIVER OF A RUSSET ROOF
WITH DEEP BLUE SHADOWS. THE BLEACHED
WOODEN GATE IS UNUSUAL, AND WHILE I
WOULDN'T USE THE COMPOSITION AS IT
NOW STANDS, I MIGHT RESTRUCTURE
THE BUILDING TO GET A MORE
INTERESTING DESIGN AND ADD SHADOW
DETAIL BY INTERLACING THE SUN AND
SHADOW OF THE GATE.

I LIKE THE RUSTIC CHARM OF ROADSIDE
FRUIT STANDS AND I WILL PROBABLY
USE ELEMENTS FROM THIS SHOT.

I ESPECIALLY LIKE THE SHAPE OF THIS
TREE AT RIGHT, AND WILL PROBABLY
INCORPORATE IT INTO A WINTER SCENE.

INTERESTING COLOR PATTERNS OF FLOWERS AND BLUE WATER, BUT IN PAINTING IT I WOULD ADD SOME LARGER TREES IN THE FOREGROUND AND CHANGE THE COMPOSITION SOMEWHAT.

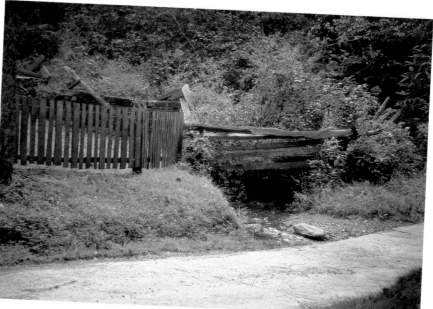

THE TEXTURE AND DETAILING ON THE FENCE IS APPEALING AGAINST THE DARK GREEN BACKGROUND, BUT I WOULD EXCLUDE THE ROAD AND USE THE FENCE WITH OTHER, BETTER-COMPOSED MATERIAL.

ANOTHER SPLIT-RAIL FENCE. THE SHADOWS ARE FASCINATING, AND I LIKE THE HISTORICAL REFERENCE OF THAT MONUMENT.

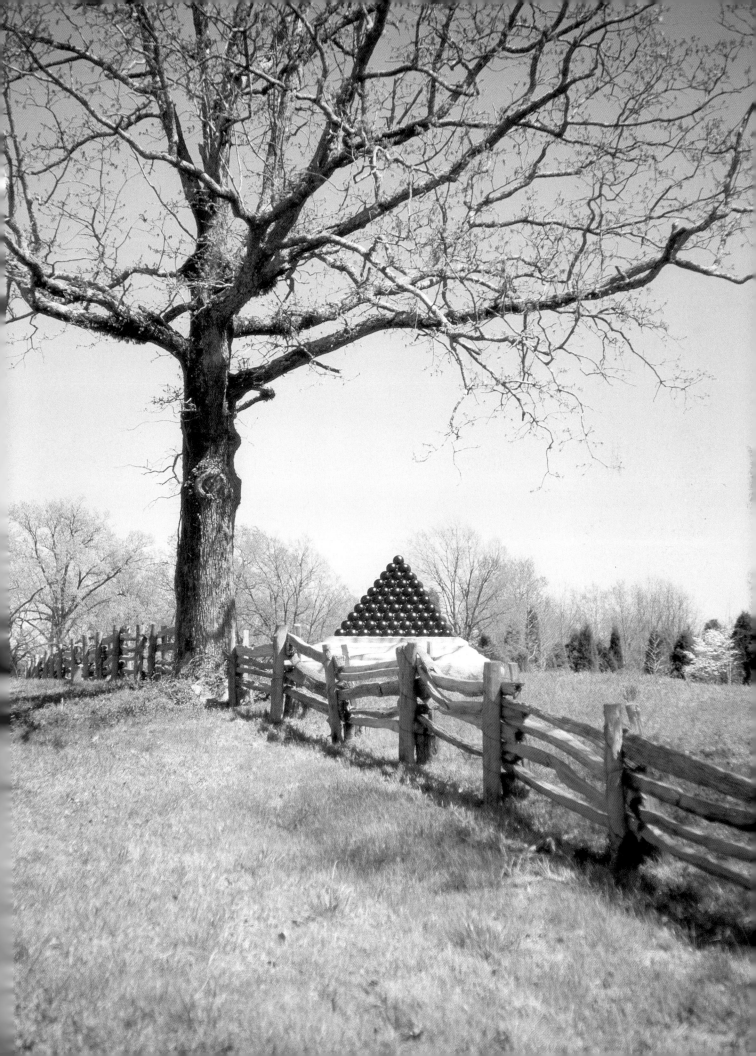

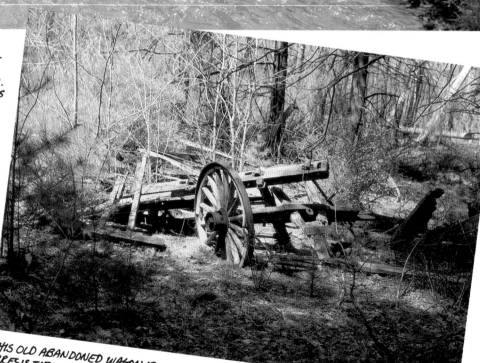

I LIKE THE COMPOSITION OF THIS PICTURE AND WOULD PROBABLY PAINT THE DANCING WATER AGAINST THE GREEN GRASSES PRETTY MUCH AS I PHOTOGRAPHED THEM. THE FENCE OVER THE STREAM MAKES THIS SCENE UNIQUE.

THIS OLD ABANDONED WAGON IS IRRESISTIBLE. THE FILTERED LIGHT HIGHLIGHTS IT, AND THE SCENE EVOKES MAN'S PRESENCE IN A VAST WILDERNESS. IT WOULD MAKE AN EXCELLENT PAINTING WITH ONLY MINOR CHANGES.

THE PHOTO AT RIGHT IS HARDLY WORTHWHILE
IN ITSELF, BUT COMBINED WITH THE
ONE BELOW — A HEAVILY OVERGROWN
ROAD AND ROCK WALL UNDER EXCELLENT
LIGHTING CONDITIONS — WOULD MAKE
A COMPELLING IMAGE.

I SUSPECT THAT THE ROAD AND FOLIAGE ARE THE MOST USABLE PARTS OF THIS PHOTO.

I'M NOT INTERESTED IN THE COMPOSITION OR SUBJECT MATTER HERE, BUT THE WOODGRAIN TEXTURE IS GOOD REFERENCE MATERIAL.

AGAIN THE STRUCTURE HOLDS LITTLE INTEREST FOR ME. I LIKE THE TEXTURE OF THE WOOD AND ROOF, AND THE PLAY OF LIGHT OFF THE SHAKE SHINGLES. I MIGHT INCORPORATE THIS INTO A PAINTING, BUT I'D DEFINITELY ELIMINATE THE TRACTOR — TOO MUNDANE!

ON THIS ONE I MIGHT REPRODUCE THE ENTIRE STRUCTURE, WITH ITS ANGULAR SOLIDITY, OR JUST CONCENTRATE ON THE WINDOWS ON THE LEFT. IN FACT, THE ENTIRE FRONT FACADE HAS POINTS OF INTEREST FOR FUTURE WORK.

29

THE ONLY INTERESTING THING HERE IS THE SHARP
CONTRAST BETWEEN THE SUNLIT AND SHADED AREAS.

A BURNED-OUT REMNANT OF PAST HISTORY — IT WOULD
REQUIRE SOME COMPOSITIONAL CHANGES, BUT IT
DOES HAVE PROMISE.

I LOVE OLD WATER TOWERS, AND THE
SHADOWS AND TEXTURE OF THIS ONE
MAKE IT A WINNER! I MIGHT WORK
THIS INTO A LARGER COMPOSITION.

I USED MY 28 MM WIDE-ANGLE LENS, BUT IT STILL TOOK TWO SHOTS FROM WHERE I STOOD TO PICTURE THE ENTIRE BARN. I SEE SEVERAL POSSIBILITIES — THE RICH ROOF AND WEATHERED WOOD, AND THE WAY THE WINDOWS REPEAT ALONG THE LENGTH OF THE STRUCTURE.

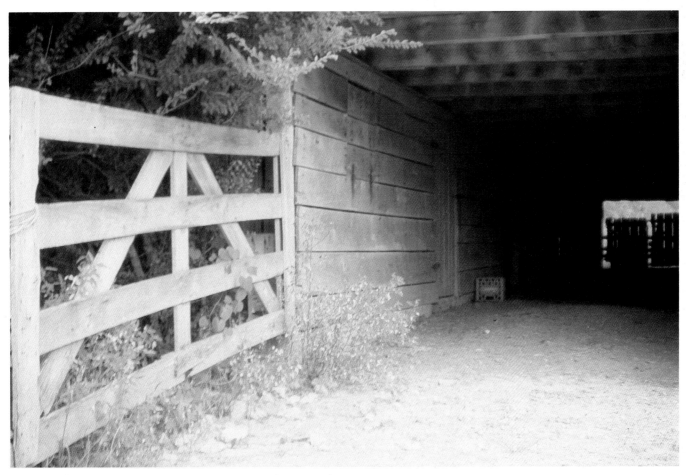

AN INSIDE VIEW OF THE SAME BARN, AGAIN WITH A 28 MM LENS. THE GATE AND INTERIOR LEAD THE EYE TO THE SUNLIGHT AT THE OTHER END. THIS SUBTLE INTERPLAY OF LIGHT AND SHADOW IS THE TYPE OF INFORMATION THE CAMERA CAPTURES SO EFFECTIVELY.

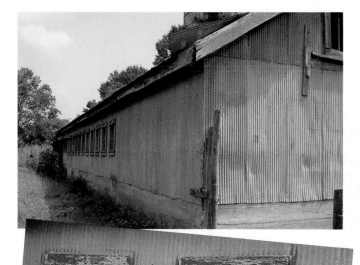

TIN IS FASCINATING FOR ITS COLOR AND TEXTURE, ESPECIALLY IN SCENES SUCH AS THIS WHERE IT IS CONTRASTED WITH THE SHADOWED AND SUNLIT GRASSES. I ALSO TOOK A CLOSEUP OF TWO OF THE WINDOWS WHICH MIGHT STAND WELL AS A PAINTING WITH NO CHANGES CONSIDERING THE RICH CONTRASTS AND THE WEATHERED AND TEXTURED MOOD IT CREATES.

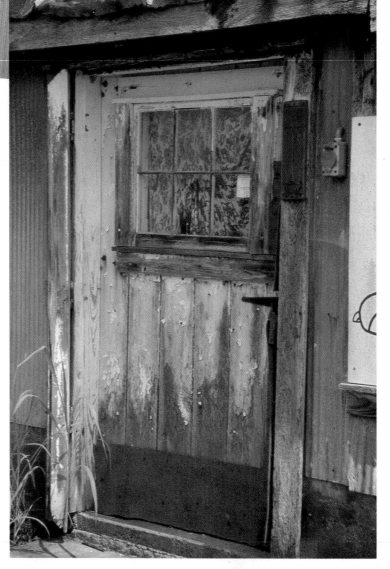

ANOTHER WEATHERED SCENE — THIS TIME A DOOR. THE FADING WHITE PAINT AGAINST THE OTHER COLORS OFFERS SEVERAL POSSIBILITIES FOR A PAINTING, EITHER ALONE OR IN CONJUNCTION WITH OTHER REFERENCE MATERIAL.

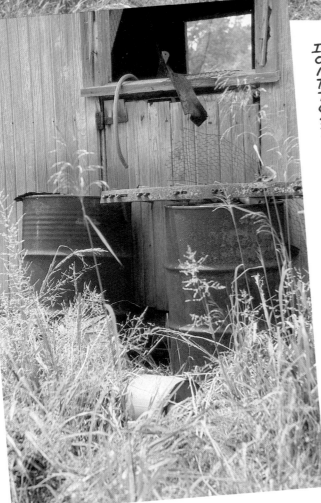

I TOOK THESE FOR THE DETAILED TEXTURE
OF WOOD AND GRASSES PLUS THE ADDED
INTEREST OF THE RUSTED BARRELS.
THIS IS A GOOD EXAMPLE OF THE USE OF
THE ZOOM LENS. I SHOT THE FIRST
ONE AT A SLIGHTLY WIDE ANGLE. THEN,
STANDING IN THE SAME SPOT, I WAS ABLE
TO ZOOM IN FOR A CLOSEUP OF THE
AREA THAT PARTICULARLY INTERESTED ME.

THESE PHOTOS ARE OF AN OLD LOG CABIN,
ONE OF THE MAIN SUBJECTS DISCOVERED
ON THIS FIELD TRIP. WHEN I FIND A
SUBJECT THAT I FEEL WILL PROVIDE
MATERIAL FOR A MAJOR PAINTING, OR
EVEN SEVERAL PAINTINGS – SUCH AS
THIS – I TAKE A LOT OF PHOTOGRAPHS.

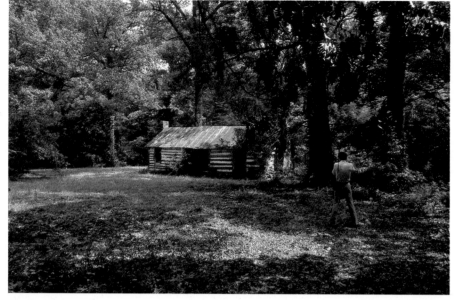

THE ARTIST STALKING THE SUBJECT.

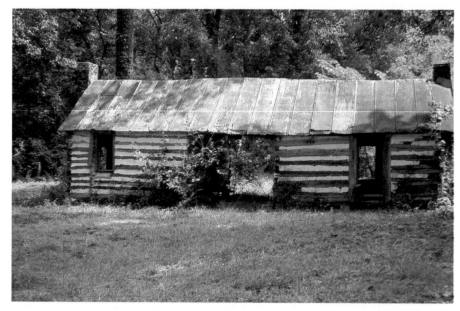

THIS STRAIGHT-ON VIEW OF THE HOUSE
SHOWS THE UNUSUAL ARCHITECTURAL
STYLE OF THE DOG TROT, WITH A
ROOM ON EITHER END. THIS IS A
SIMPLE LOG CABIN THAT FAMILIES
WOULD BUILD IN A CLEARED-OUT AREA
OF THE WOODS OVER A HUNDRED
YEARS AGO.

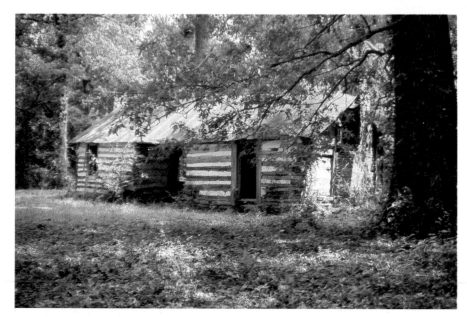

ANOTHER VIEW OF THE CABIN, THIS
TIME EXPLORING THE FINE SUNLIGHT
THAT FILTERS THROUGH THE TREETOPS.

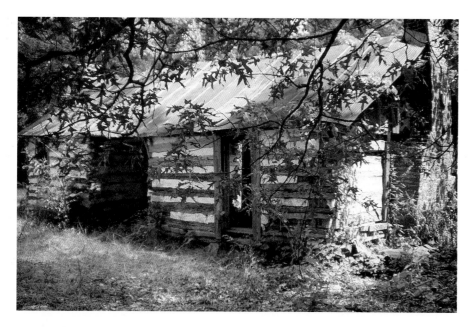

A ZOOM SHOT FROM THE SAME POSITION FOR A CLOSER VIEW OF THE DETAILS OF THE BUILDING.

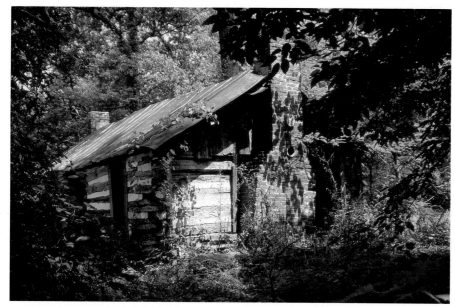

I MOVED TO THE RIGHT END OF THE HOUSE AND SHOT THIS THROUGH THE TREES. I WAS ABLE TO PICK UP THE CHIMNEY AND THE REAR OF THE HOUSE, OVERGROWN WITH FOLIAGE.

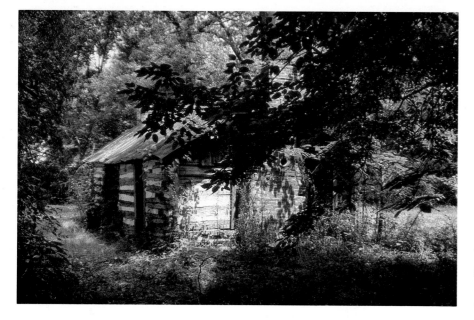

THE ZOOM LENS WAS PULLED BACK TO A WIDER FOCAL LENGTH TO EXPLORE THE RELATIONSHIP BETWEEN THE STRUCTURE AND THE OVERHANGING FOLIAGE.

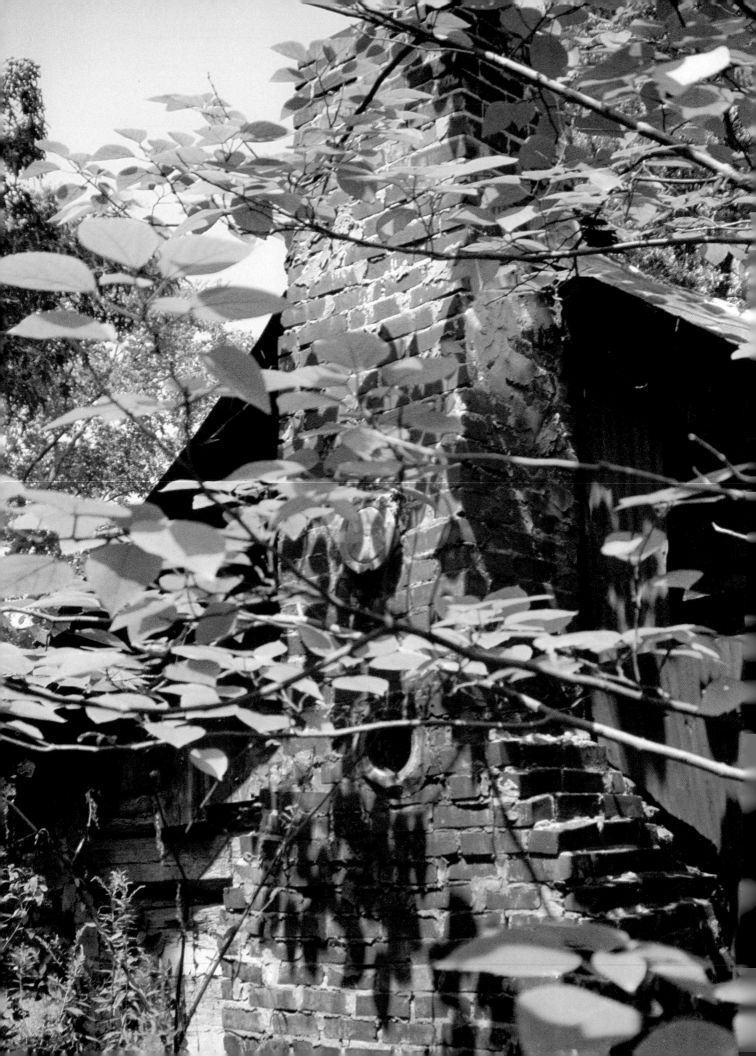

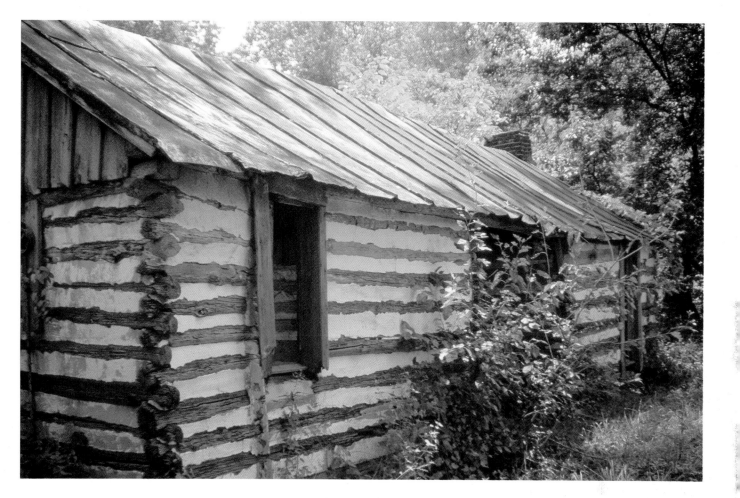

AT LEFT IS A CLOSEUP OF THE CHIMNEY, ITS PATTERN BROKEN WITH FOLIAGE
AND SHADOWS. OFTEN CLOSER VIEWS OF STRUCTURES CAN PROVIDE ME
WITH MATERIAL FOR DIFFERING TYPES OF PAINTINGS. IN FACT, IF THIS
PICTURE WERE THROWN OUT OF FOCUS, IT WOULD PRODUCE A FINE
PATTERN OF LIGHTS AND DARKS THAT MIGHT SERVE AS THE NUCLEUS OF
AN ABSTRACT PAINTING.
THE SHOT ABOVE IS FROM THE OTHER END OF THE HOUSE. NOTE THE
EXAGGERATED PERSPECTIVE THIS ANGLE OFFERS.

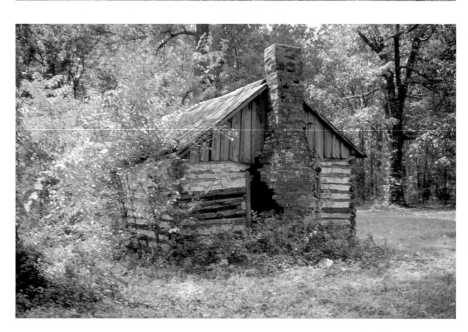

I'M TRYING TO CONSIDER ALL THE ANGLES THAT MIGHT OFFER MATERIAL FOR A PAINTING.

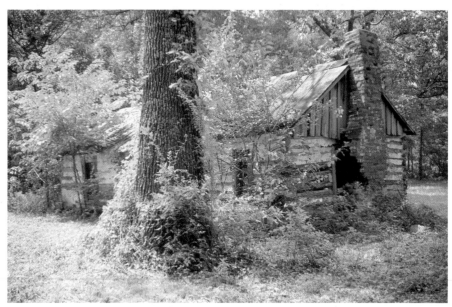

THIS VIEW SHOWS THE WEATHERED CHIMNEY QUITE NICELY.

THIS ALSO SHOWS THE CHIMNEY, BUT I INCLUDED THE LARGE TREE THIS TIME TO BREAK UP THE LINES OF THE CABIN ITSELF.

THE TEXTURES SHOW UP WELL IN THIS VIEW, AND THIS MIGHT DO WELL AS A PAINTING IN ITSELF. THE COLOR CONTRAST OF THE LOGS AND THE WEATHER SEAL, ALONG WITH THE TEXTURE OF THE ROOF OVERHANG IS COMPELLING. I ALSO LIKE THE ESCAPE FOR THE VIEWERS EYE THROUGH THE REAR WINDOW, ADDING DEPTH TO AN OTHERWISE FLAT IMAGE. BELOW IS MY FINAL SHOT OF THIS SUBJECT, SHOWING THE REAR VIEW, WHICH IS PRACTICALLY HIDDEN BY OVERGROWN WEEDS AND SHRUBS.

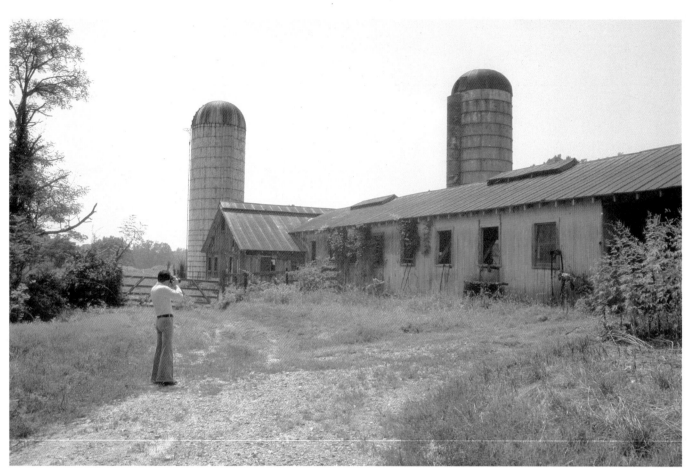

SHORTLY AFTER LEAVING THE LOG CABIN I FOUND A FARM STRUCTURE THAT INCLUDES TWO VERY FINE SILOS. I WAS ATTRACTED TO THE INTERESTING PERSPECTIVE OF THE LINEAR BUILDINGS WITH THE VERTICAL SILOS ARRESTING THE HORIZONTAL FLOW.

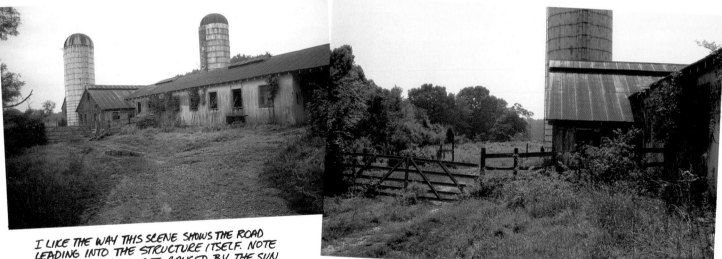

I LIKE THE WAY THIS SCENE SHOWS THE ROAD LEADING INTO THE STRUCTURE ITSELF. NOTE THE COLOR CHANGES CAUSED BY THE SUN GOING BEHIND A CLOUD.

IN THIS SHOT THE STRONG LINES OF THE BUILDING ARE COMPLEMENTED BY THE DIAGONAL ROAD.

40

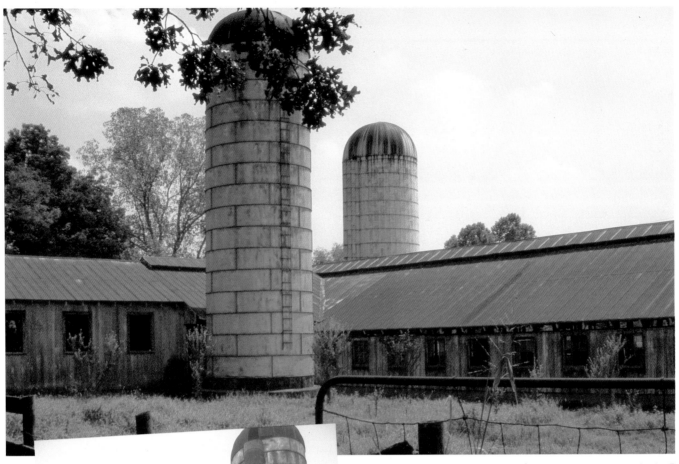

THIS VIEW IS ALMOST SERENE, WITH STRONG ANGLES FLOWING TOGETHER INTO A UNIFIED WHOLE.

A CLOSER VIEW OF THE BUILDING, OVERGROWN WITH WEEDS AND VINES. THIS IS AN ABANDONED DAIRY BARN, AND THIS ANGLE WAS TAKEN FROM THE PASTURE WHERE THE COWS WERE KEPT.

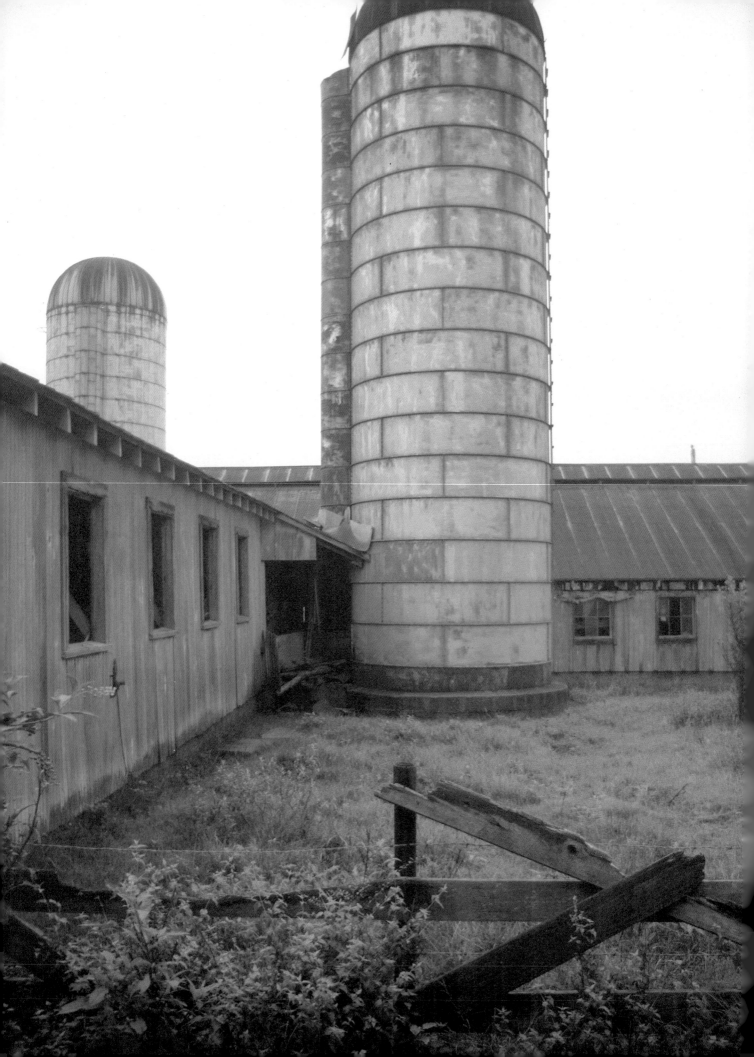

THE EXTREME ANGLE OF THE SHOT ON THE OPPOSITE PAGE REVEALS THE STRONG LINEAR FLOW OF THE BUILDING STOPPED BY THE MASSIVE UPWARD THRUST OF THE SILO. THE SECOND, SEEMINGLY SMALLER SILO GIVES AN ADDED COMPLEMENT TO THE DYNAMICS OF THIS SCENE.

SINCE IT WAS TURNING CLOUDY I STARTED FOR HOME. THE THREE SHOTS ON THIS PAGE WERE TAKEN ON THE DRIVE BACK TO TOWN.

THIS ONE HAS PROMISE, ALTHOUGH I DIDN'T TAKE THE TIME TO SWAP MY 28MM LENS FOR THE ZOOM, WHICH WOULD HAVE BROUGHT THIS BARN IN CLOSER. OH WELL, PERHAPS NEXT TIME!

A NICE MEADOW SCENE. THAT HUGE BALE OF HAY MAKES A NICE DESIGN ELEMENT, USEFUL PERHAPS IN ANOTHER CONTEXT.

ANOTHER SCENE WHICH I MIGHT WORK INTO A LANDSCAPE. THE RAIN REALLY BEGAN TO COME DOWN AT THIS POINT, SO I CALLED IT QUITS AND HEADED HOME.

43

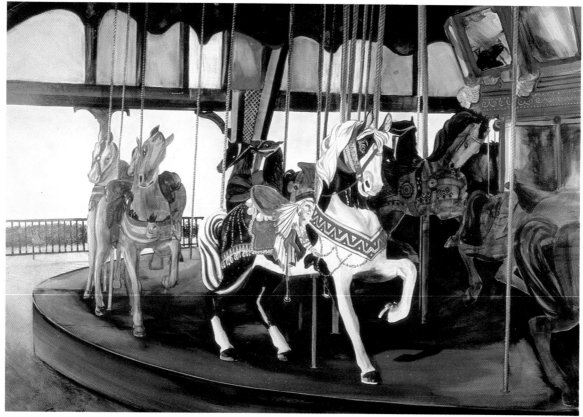

"PINTO PONY"

TRANSFORMING PHOTOS INTO PAINTINGS

Working with Photos

As I have said earlier, I think of my camera as the means of creating a space-age sketchbook by offering me a quick and easy way to record my visual impressions. But it is really much more. It is also a way of capturing incredible detail and qualities of light that are so elusive to the eye. Since photos yield so much information, I have found them to be a richer source of reference material for my paintings than sketches.

The painting *Window Baskets* is a case in point: I came across the scene while strolling among some abandoned buildings in downtown Memphis and was intrigued by the way the sun illuminated the baskets. I knew that the light and shadows would change rapidly, so I shot several slides from different angles to capture the shifting tones and textures. Because I photographed the scene instead of sketching it, I was able to get four good aspects of it in the space of a few seconds.

After some deliberation, I decided to paint the close-up scene. But not too literally! I deliberately had a black-and-white print made to prevent my being influenced by the overly saturated colors of the slide. Then I had another print made in the reverse or "flopped" position—I do this sometimes to create a more "comfortable" composition or to allow myself to get that much further from a literal interpretation of a photograph.

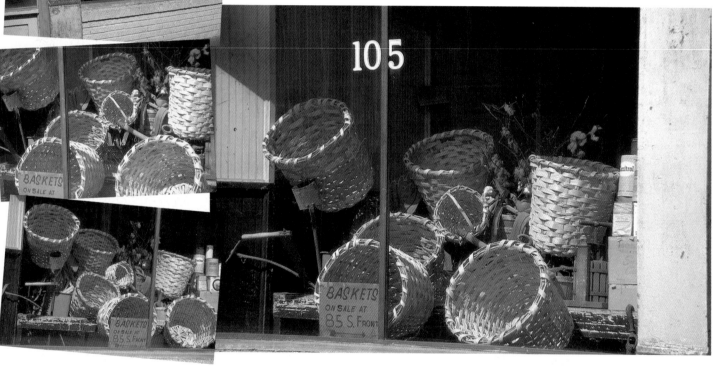

I TOOK SEVERAL REFERENCE PHOTOS, AND ENLARGED THE BEST ONE INTO AN 8"×10" (20×25CM) BLACK-AND-WHITE PRINT (TOP RIGHT). I ALSO MADE A "FLOPPED" VERSION (RIGHT).

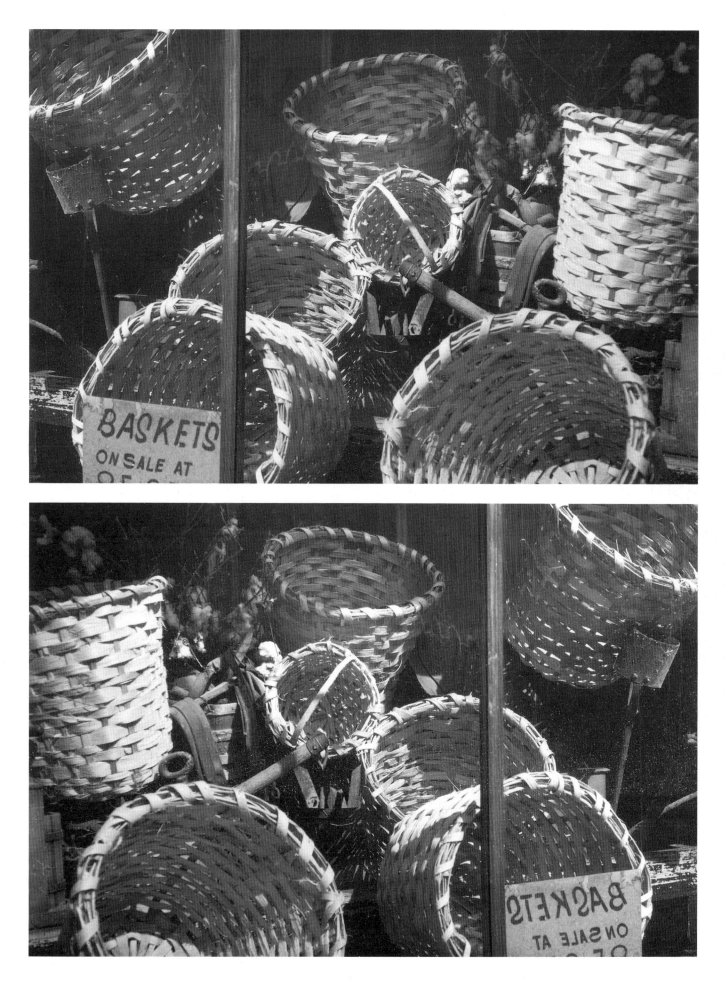

Procedure. I did a fairly detailed drawing on Strathmore Hi-Plate Illustration Board No. 240-4. This surface has the advantage of allowing me to develop a single area to completion rather than work on the overall painting all at once. I used new gamboge, raw umber, and raw sienna as underwashes for the baskets, then used burnt umber, burnt sienna, Prussian blue, and Van Dyke brown for the detail and shadows. Some of the lighter shadows were done with Winsor blue and burnt sienna. Also, cadmium red medium was used to intensify the shadow area.

The completed painting is a detailed interpretation, yet there are value changes and areas of soft detail that evoke the exact mood I wanted. Rather than being a slavish imitation of the reference photograph, this painting is my interpretation of the subject, done with the *aid* of photography.

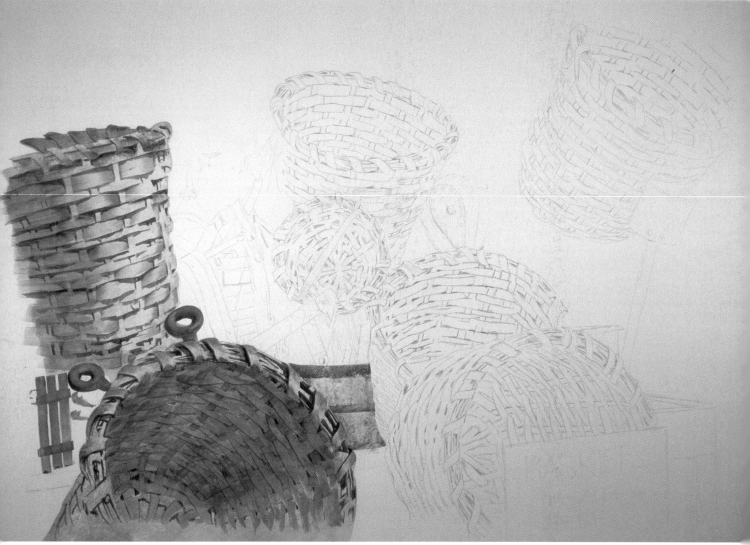

EARLY STAGE

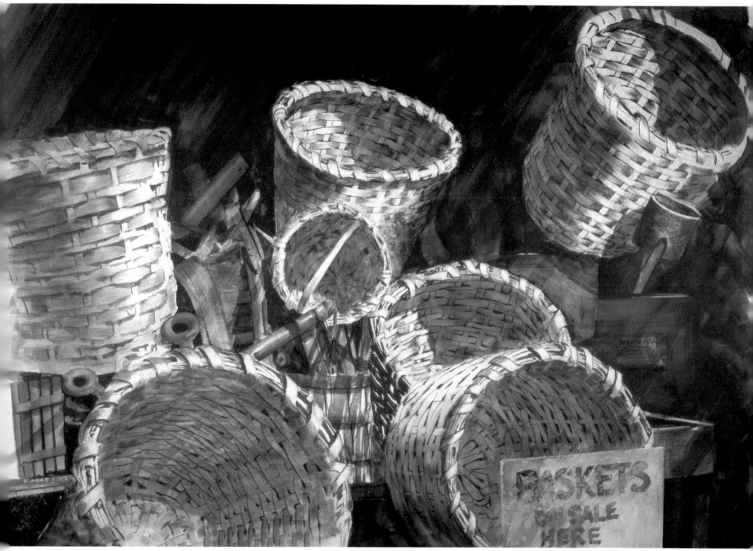

FINISHED PAINTING

"WINDOW BASKETS"

Transferring Photos: The Grid System

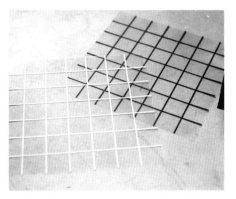

The method I use to translate a reference photograph into a preliminary drawing or painting is one that has been used by master artists down through the years. It is called the "Grid system," and it is a handy means of quickly translating a visual reference onto the board or paper. It is quite accurate, although it does allow you to take artistic license and change the proportions, perspective, or composition of the available image.

My method is to use grid sheets that I have transferred onto sheets of acetate or Mylar, which is a stable-based material. I have a black grid and a white grid, and I use them as overlays to cover the screen of my slide viewer. The illustrations show the two grid sheets, with the individual black and white grids in position. The black one works better when used over a light slide, and the white one works better over a dark slide.

When I want to use the grid system, I lay the grid sheet over the image to be enlarged. Meanwhile, I have blocked off my painting board into a grid also, with squares of perhaps two or four inches (5 or 10cm), or whatever size enlargement I plan to make. Since the acetate grid is divided into one-inch (2.5cm) squares, the scale would be 1:2 or 1:4 or 1 to whatever the size grid is on the painting board. Then it is simply a matter of translating the smaller image, broken by the grid into squares, into the larger corresponding squares on the painting surface. Thus the image is transferred proportionally onto the larger surface.

This, in my opinion, is the best means of translating a photographic reference material into drawings or paintings. There are other means, of course, such as projecting the image and tracing it. But I cannot endorse this method since I feel that it lacks spontaneity and the creative element that artists can put into painting. Another means of translating an image into a painting is through the use of a pantograph, but that is a somewhat antiquated instrument and is seldom used nowadays. The pantograph is a complex machine with which the artist traces over a visual image using a point, while at the other end of the pantograph, a pencil point transfers these movements into an enlarged image. I have never found this tool to work very well and hence do not recommend it very highly. I still find the grid system to be the most effective means of transferring images into painting. I also use this method to enlarge a small sketch into a larger area in preparation for a painting.

BLACK AND WHITE GRIDS ON ACETATE ARE PLACED ON THE SLIDE VIEWER.

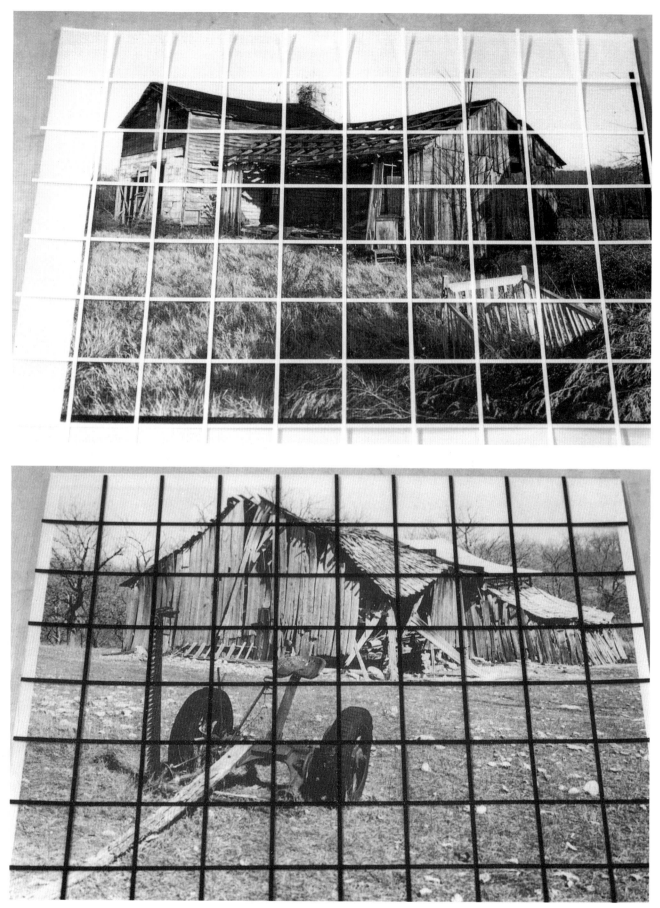

HERE THE GRIDS ARE ON PHOTOGRAPHS.

Selecting the Best Photo

This demonstration is intended to show how I edit and select from the wealth of reference material that a camera provides. The subject is Josh, the son of a friend, and I shot several reference photographs of him while on a visit to his parents' house. After getting left, right, straight-on, and three-quarter views, I took written notes of his facial idiosyncracies, as I often do with portrait work. Every face is unique, and I noted Josh's tendencies to wrinkle his nose and purse his lips in a certain way, the impish look in his eyes, and so on. All these details help me to capture the character of a subject when I'm doing my preliminary sketches.

From among the many photographs I took, I chose the six shown here for serious consideration. Before selecting one for the final portrait, I created a five-image sketch, paying particular attention to the likenesses that reflected the subject's personality. My final selection was a three-quarter view with Josh looking straight at the camera.

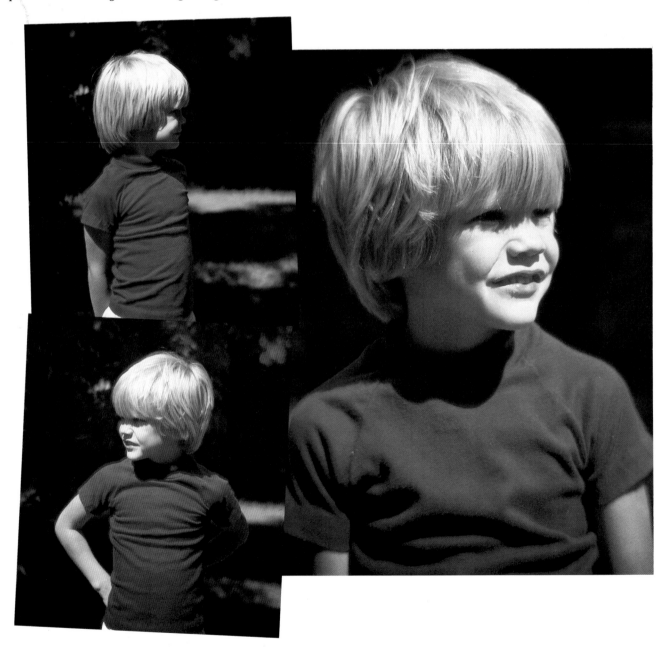

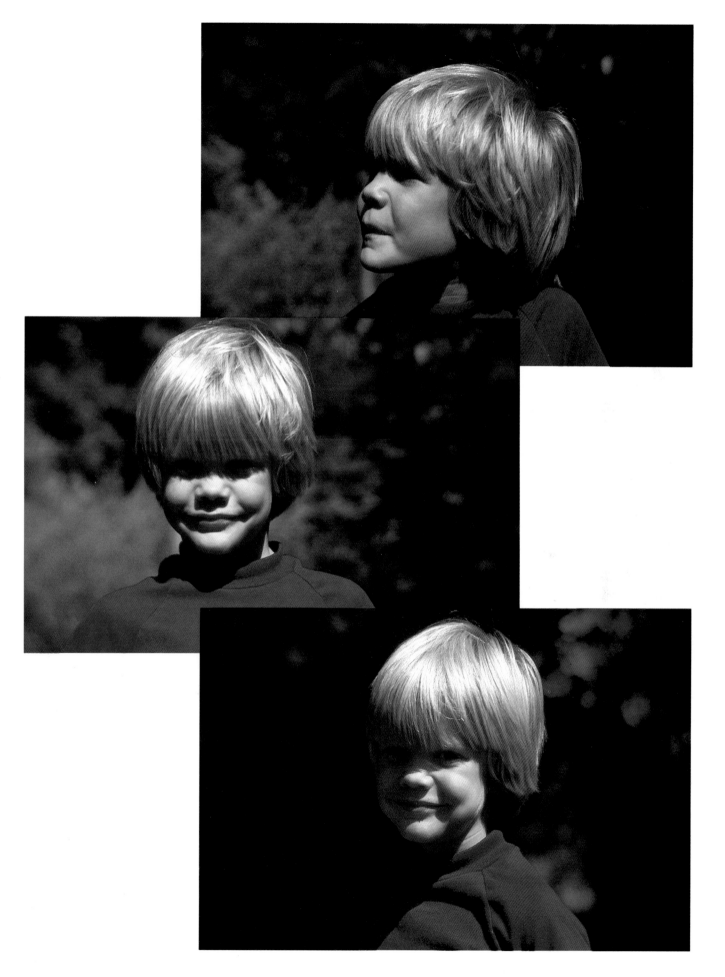

Sketch. I began by creating a detailed pencil drawing of Josh with a soft pencil on high-plate illustration board. Then I began to execute the watercolor portrait. I blocked in a wash of neutral gray for the background, since I wanted to keep the portrait as simple as possible. After all, there is a beautiful simplicity about children, and I wanted nothing to detract from the high-spirited look in his eyes, the devilish grin, the dimples from his smile. These details are the essence of children's portraiture.

Colors. I used cadmium red and burnt umber for the skin tones, cadmium yellow and yellow ochre for the hair, with burnt umber and Prussian blue for the shadow detail in the hair. The eyes are cerulean blue, while their shadows are a mixture of Prussian blue and Van Dyke brown. Finally, cerulean blue was roughly blocked in to suggest the shirt, but not define it too distinctly.

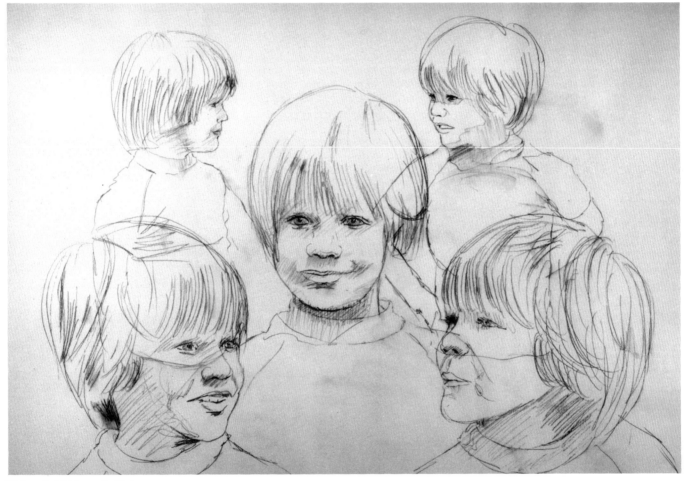

FIVE-IMAGE SKETCH

INITIAL DRAWING

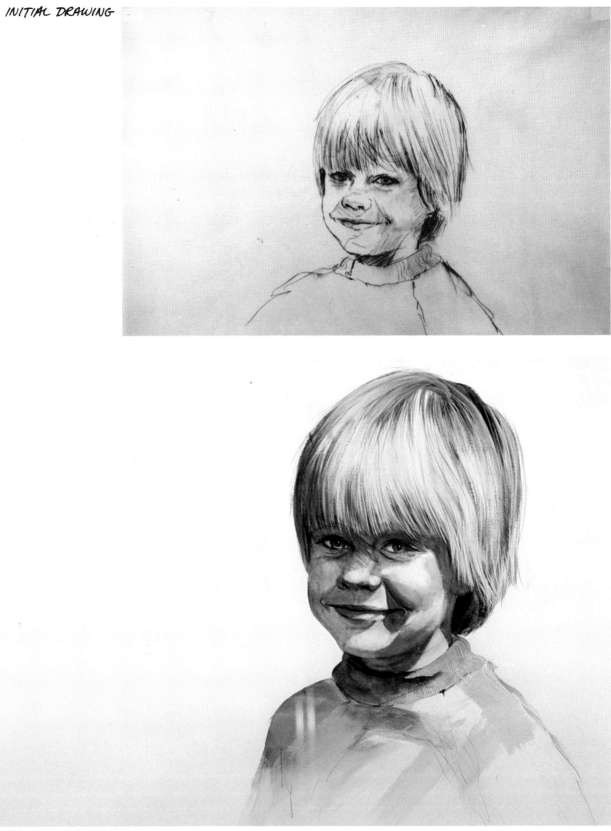

FINISHED PORTRAIT

"JOSH"

55

Modifying the Photo

There is no limit to the changes an artist can make when using reference photographs. The seasons can be changed; the terrain can be made hilly or flat; and the light, color, and intensity can all be altered at will. The mailboxes were composed from bits of reference material. But I changed the direction of the road so that it wound back into the painting. I also changed the season to winter, and created a horizon to show the sky and the disappearing road. In other words, I utilized this material to create a painting that totally reflects my emotional response to this subject.

Procedure. I used the grid system to enlarge the details of these mailboxes. Then I painted the sky with Davy's gray with a little mixture of Winsor blue and burnt sienna, and created the dead russet grasses with a mixture of burnt sienna and burnt umber. The darker grasses were a mixture of Van Dyke brown and Prussian blue, and I created some evergreens with Prussian blue and Van Dyke brown to offset the warm russets of the winter grasses.

Notice that I used a resist to keep paint off the mailboxes. I left this area for last so I could determine the color density and detail best suited for the boxes, the obvious center of interest. When the rest of the painting was completed, I removed the resist and painted the wooden frame Davy's gray. I added shadows of Prussian blue and Van Dyke brown to it, too, since the sun casts faint shadows, even in wintertime. The metal mailboxes are mixtures of burnt sienna and Winsor blue in varying proportions, with Prussian-blue and Van Dyke-brown detailing. The gift box in the mailbox has a cadmium red ribbon. Finally, I spattered opaque white onto the foreground area to simulate falling snow.

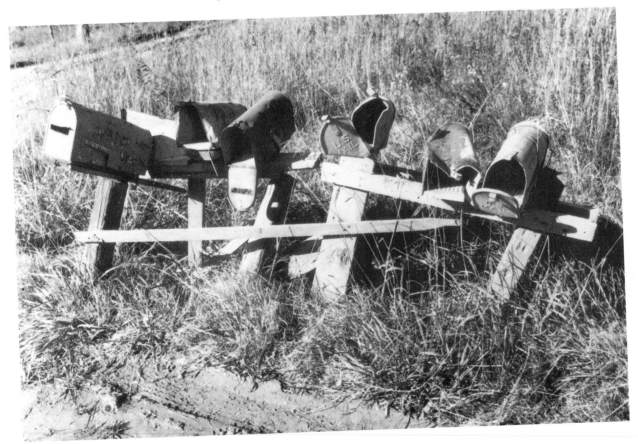

REFERENCE PHOTO

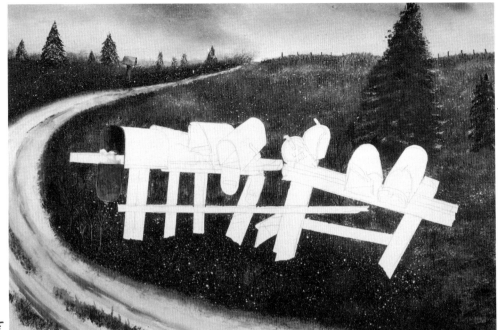

INTERMEDIATE STAGE

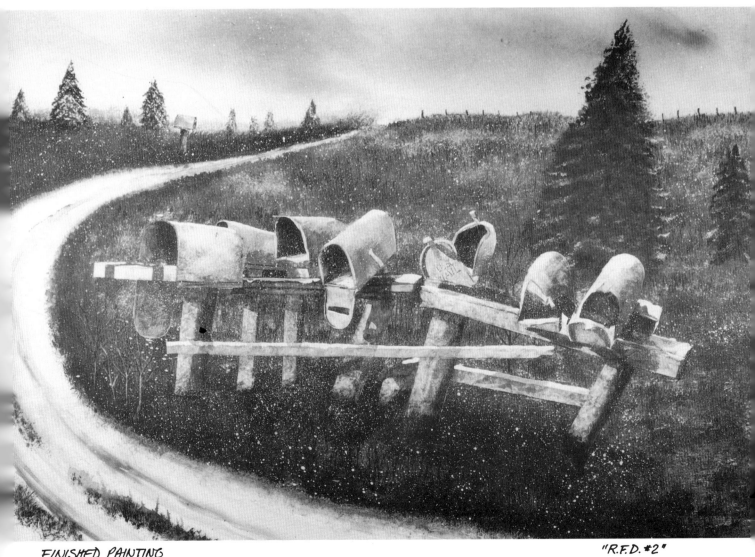

FINISHED PAINTING

"R.F.D. #2"

Eliminating Detail

This demonstration concerns the elimination of detail. I wanted to create a very placid body of water with delicate reflections contrasting against the strength and hardness of the granite boulder, and I felt that too much detail would detract from this goal.

Sketches. I began by sketching the scene. The first sketch is a partial likeness of the photograph, not totally literal, but at least somewhat close to the reference photograph. This sketch contains the trees and still water in the foreground, with some additional trees in the distance. But I wanted to keep my final painting simple in order to emphasize the water and its reflections, and to focus on the beautiful texture of the boulder. Therefore I did another sketch in which I eliminated the trees in the foreground and also a considerable number of those in the background, creating a more peaceful version of this particular scene. Then I developed the middle area of the painting, paying close attention to the strata and texture of the boulder, and indicating the density of the tree foliage to the right of the rock.

SKETCHED "AS IS" FROM PHOTO

Intermediate Stage. In the photograph of the unfinished painting, notice that I was trying to warm the middle ground beneath the boulder by playing one color temperature against another. At this point, I also blocked in the foreground and put some color in the sky. But I wanted a cooler feeling, so I intensified the color of the trees in the background and foreground, particularly that of the evergreens, and I made the body of water on the other side of the land mass more evident, creating a repeated sliver of blue between the middle and background of the painting.

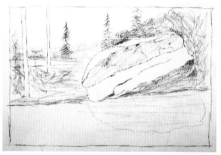

DETAIL ELIMINATED

Final Painting. I used a Winsor blue and Davy's gray mixture in the sky, and a very diluted Van Dyke brown and Prussian blue combination for the distant evergreens, and olive green with burnt sienna for the tree foliage to the right of and behind the boulder. For the boulder itself, I used Davy's gray, with Prussian blue and Van Dyke brown for the shadow detail, and a diluted burnt sienna for the warmer tones on the boulder. I used the stiff bristle brush technique to create the texture of the grasses with olive green and burnt sienna, and I blocked in the water with Winsor blue, allowed it to dry, then I added a mixture of Van Dyke brown and Prussian blue to create a dark reflection along the bank's edge. While this was still wet, I pulled in some highlights and indicated some of the reflection of the boulder.

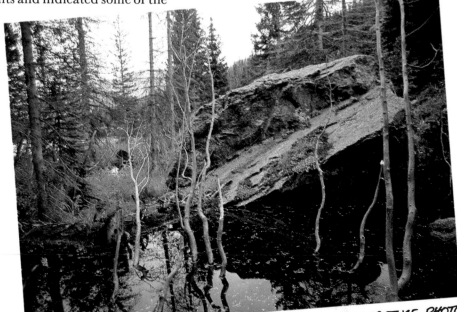

REFERENCE PHOTO

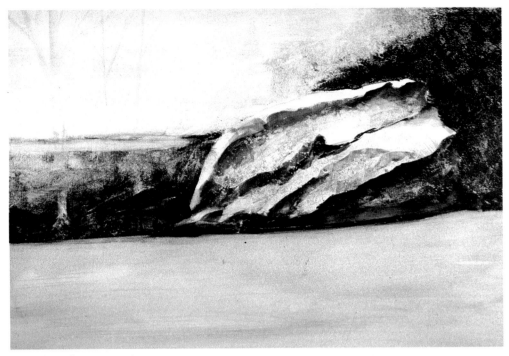

INTERMEDIATE STAGE

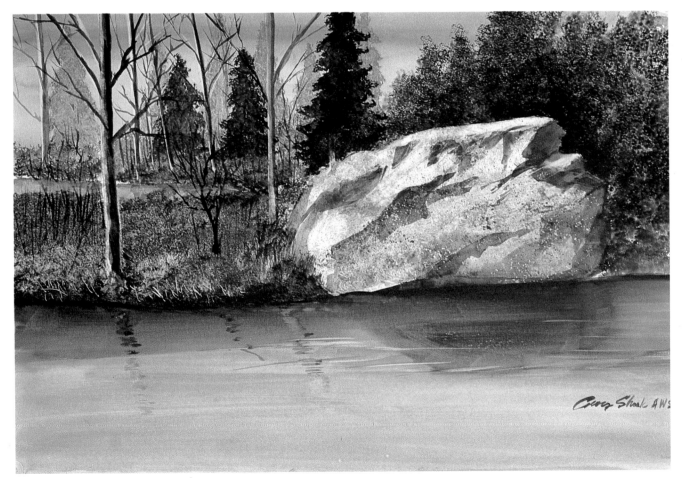

FINISHED PAINTING

"EVERGREEN BOULDER"

Changing the Season

The purpose of this demonstration is to utilize a single reference work to create views of the same scene throughout the four seasons. In this instance I used a color photograph rather than a slide as reference material. Although the overall tone of the photograph is somewhat warm, it is actually a view of the Strawberry River during wintertime.

It is with this single image of winter that I began, although I suspect the results would have been the same regardless of the season depicted in the reference photograph. This is because the effort was mostly one of imagination, trying to conjure images of the seasons and the changes they bring to the countryside.

To achieve consistency among the four images, I used the grid system to execute four very similar drawings. Nevertheless, I did not concern myself with exact detail. I just utilized the best of the reference photograph, and I would not have hesitated to include elements from other sources or to rearrange existing elements had the situation called for it. My only concern was to achieve a strong design and composition for the final painting.

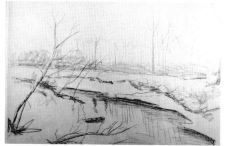

PENCIL SKETCH

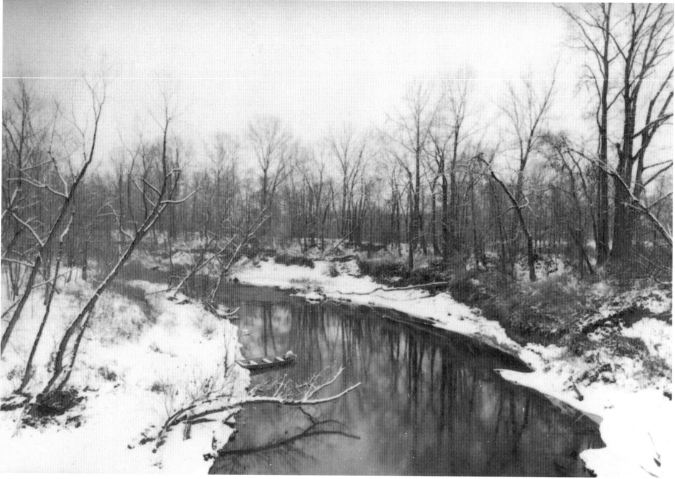

PHOTO OF STRAWBERRY RIVER

Winter. To depict winter, rather than literally copy the reference photograph, I executed my own interpretation of the river at this time of year. I washed in the sky primarily with Davy's gray, not quite as a monochrome but lacking real color because I wanted to convey the dreariness and desolation of wintertime on a deserted river. The fallen snow is actually the white of the board itself, though I also used opaque white to create the illusion of falling snow. The background foliage is a mixture of Prussian blue and Van Dyke brown, with the strongest color being the dead grasses—a mixture of burnt sienna with a little Prussian blue and Van Dyke brown for added density. I used a heavier concentration of burnt sienna on the left bank, with a Prussian blue and Van Dyke brown mix for the darkest dark of the trees and the shadows along the river's edge. The water is Prussian blue, with burnt sienna to suggest the reflection of grasses along the bank. The illusion of falling snow was accomplished by flicking opaque white pigment onto the board. The stippled effect was done by drawing a fingernail across a stiff bristle brush loaded with opaque white pigment. The effect is of snow falling onto the river and surrounding landscape.

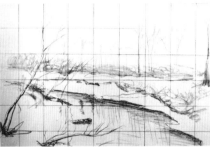

WITH GRID

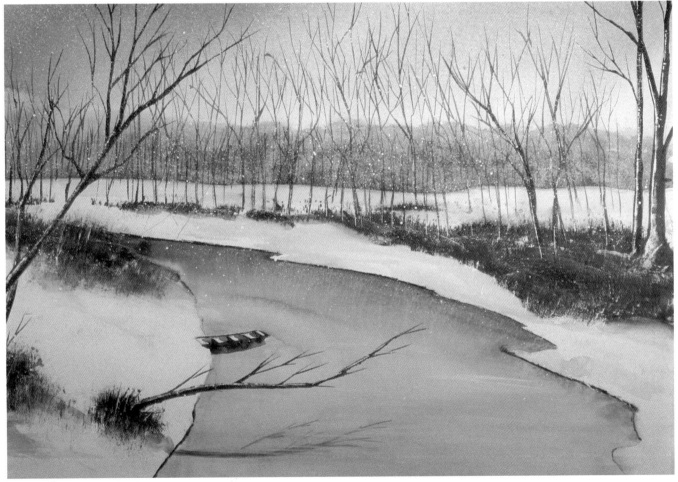

WINTER

Spring. In the painting, *Spring*, I tried to achieve the light green, wispy look of trees as they begin budding and as the riverbanks just begin to support foliage. In short, the annual renewal of promise. I used a mixture of burnt sienna, Winsor blue, and raw sienna for the ground; burnt sienna and Winsor blue for the riverbank; raw sienna, raw umber, and burnt umber along the water's edge; and olive green on the left riverbank. I used a mixture of Winsor blue and Davy's gray for the sky; olive green mixed with cadmium yellow for the tree leaves; Winsor blue for the water; a Prussian blue and Van Dyke brown for the shadow details; and olive green for the reflection of the trees in the water.

Summer. Summertime is a time of fullness, so in *Summer*, I created a more intense sky with Winsor blue mixed with Davy's gray. I increased the density of green in the foliage with more olive green, and added a mixture of Prussian blue and Van Dyke brown to the olive green for the darker, distant foliage. I also added more burnt sienna on the riverbank, more Winsor blue in the water, and mixed olive green with burnt umber for the left dirt bank. The shadow detail is again a mixture of Prussian blue and Van Dyke brown. I hoped greater intensity would suggest the nature of a lazy summer day, full of character and calm.

Fall. Fall is the point at which the trees are beginning to turn colors and lose their heavy summer foliage. I used more burnt sienna and added brown madder to achieve the darkened effect. A lighter Winsor blue was used in the sky, a burnt sienna for the riverbanks, and olive green was mixed with burnt sienna for the grasses. I used a heavy burnt sienna on the left bank to suggest the dying grasses of fall. The water is Prussian blue, and the reflected shadows are a mixture of Van Dyke brown and Prussian blue. The bright red of the tree foliage is cadmium red, while the yellowish foliage is a mixture of cadmium yellow and yellow ochre.

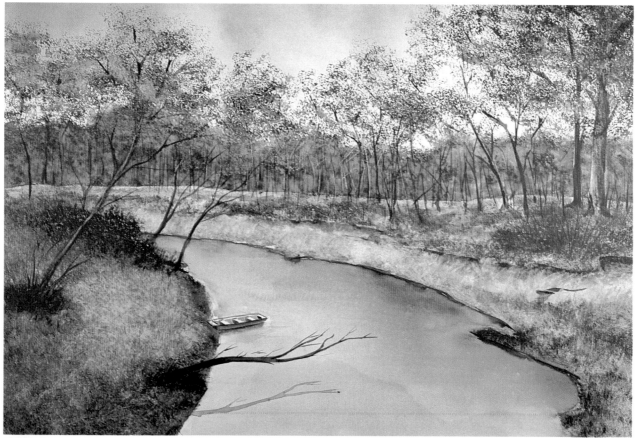

SPRING

62

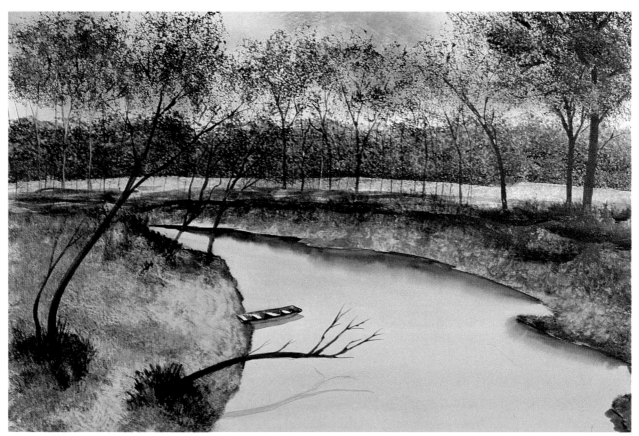

SUMMER

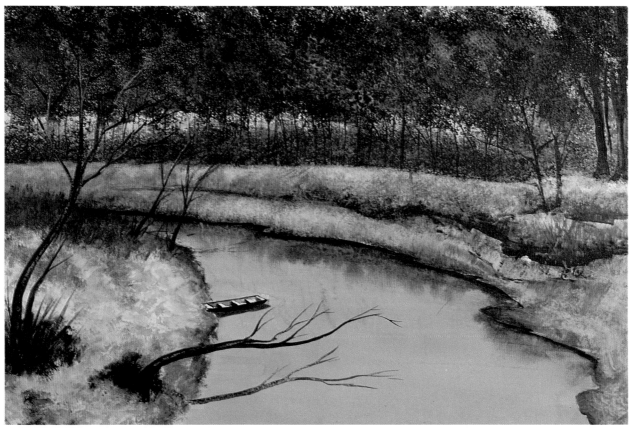

FALL

Changing the Time of Day

Using a photograph of an old building in shadow and additional buildings seen in silhouette after a snowfall, I will now demonstrate how to change the time of day in a photograph, along with the necessary lighting and color changes.

Day. In the day scene, I changed the lighting situation of the photograph just enough to cast a shadow, and eliminated the extraneous trees and building. I paid more attention to detail in the door to indicate cast shadows, and created a shadow for the building in the background. The colors used were Davy's gray and Winsor blue for the sky, raw umber and raw sienna for the grass, and some burnt sienna in the foreground grass. I used Van Dyke brown, Prussian blue, and burnt sienna for the background buildings, and added cadmium red and Davy's gray for the bricks and wood in the main building. The windows were done with a Winsor blue and burnt sienna mixture, with Van Dyke brown for shadow detail.

Night. To transform this painting into a night scene, I used the same combination of colors, but glazed ultramarine blue over the paint when it was dry. As for the grasses, on the other hand, I mixed ultramarine blue into the daytime colors at the same time I was painting, and added some dark values to the building with a mixture of ultramarine blue and a small amount of burnt umber. I used cadmium yellow in the window areas, and washed out any detail of the window, even allowing a bit of the white paper to show through. I also added a saturated cadmium yellow to the upper right-hand corner of the window to indicate light being cast from the inside.

In conclusion, I have used the same basic colors in the night scene as in the day scene, the difference being the additional burnt umber and ultramarine blue in the building and grasses and, of course, the additional color of the light itself.

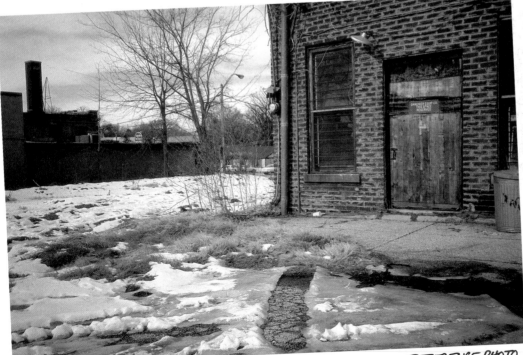

REFERENCE PHOTO

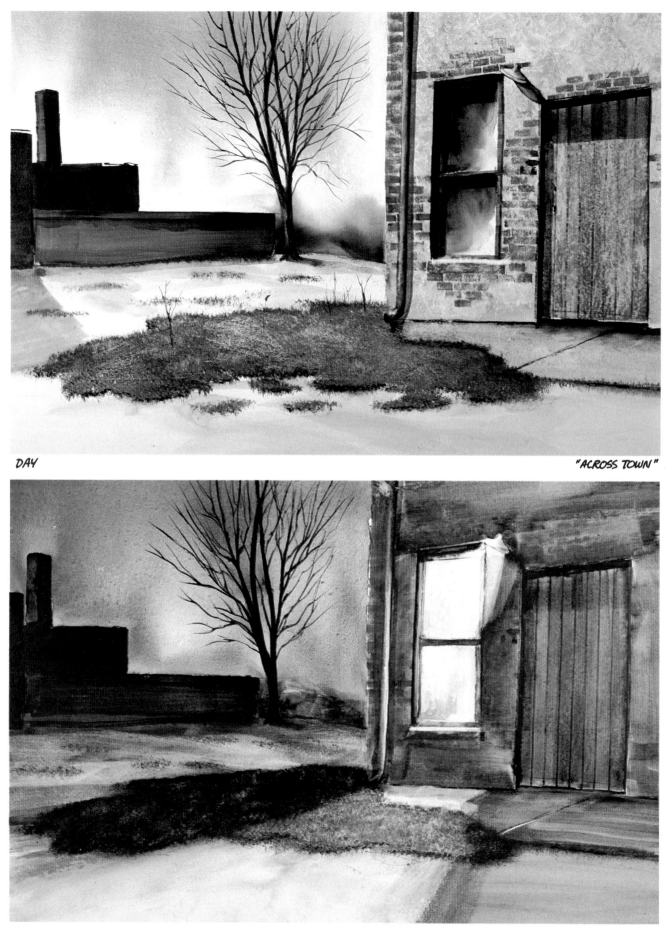

DAY "ACROSS TOWN"

NIGHT "ACROSS TOWN"

65

Changing the Location

Here is an example of two reference photographs from two entirely different geographical locations combined into a simple painting with a suitable composition and a nice contrast of elements. My first photograph has a pleasing background of fog, but the water is unexciting. Since I wanted the contrast of rapidly flowing water, I combined elements from a second photograph of rushing water with elements from the first photograph.

Sketches. Sketches 1 and 2 are fairly literal interpretations of the reference photographs they were taken from, but the third sketch combines elements of both. In fact, I took the background from the first photograph and the middle and foreground from the second photograph. Not only is the composition of the third sketch more interesting, but I think that the contrast of the turbulent water and the peaceful background adds to the drama.

Colors. The sky is Winsor blue and the evergreens are a mix of Prussian blue and Van Dyke brown. I used a more diluted mixture of the same colors to paint the misty trees in the background, while the large masses of foliage on the left are composed of olive green, with a Prussian blue and Van Dyke brown mixture for the shadow detail. Burnt sienna and ultramarine blue added shadow to the water, and the rock was painted Davy's gray with a mixture of burnt sienna and ultramarine blue for the shadows. I used cerulean blue in the highlit area of the water, but the white water is actually the white of the board. I did use opaque white, however, to achieve the effect of the water splashing against the rock.

REFERENCE PHOTOS

66

SKETCH FOR BACKGROUND

SKETCH FOR FOREGROUND

COMBINING BOTH SCENES

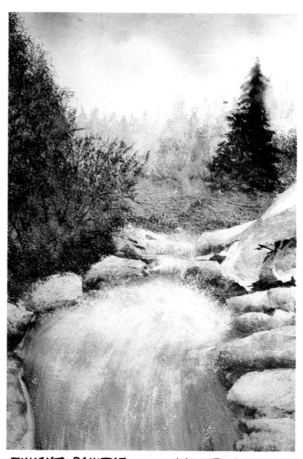

FINISHED PAINTING "MOUNTAIN STREAM"

Making a Panorama

Many times when I am on location gathering material for a painting I see a lovely view that is too wide to capture, even with my 28mm lens. The entire scene just will not fit within the viewfinder of the camera. I solve this dilemma by creating a set of adjoining shots that, when joined together, form a panoramic view of the entire scene.

Of course, a tripod is helpful in achieving the critical alignment necessary, but I have used a fence or ledge or even leaned against a tree to steady the camera and keep it parallel to the horizon.

The photos shown here are of a view of downtown Memphis, Tennessee, showing the new tram bridge that carries visitors from the downtown area to the new Mud Island complex. Notice that I overlapped the objects shown in these images for better registration. In other words, it is easier to connect the photos when the edge of one picture includes a point of reference that can be matched with the same subject on the adjoining photograph. Looking at the sketch, it's hard to believe that a combination of three different photographs was used.

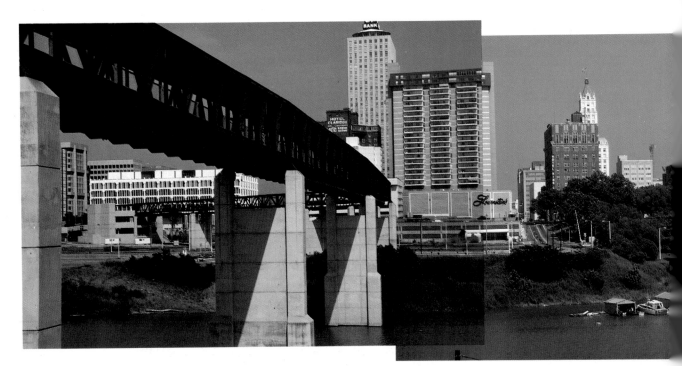

PANORAMIC SKETCH

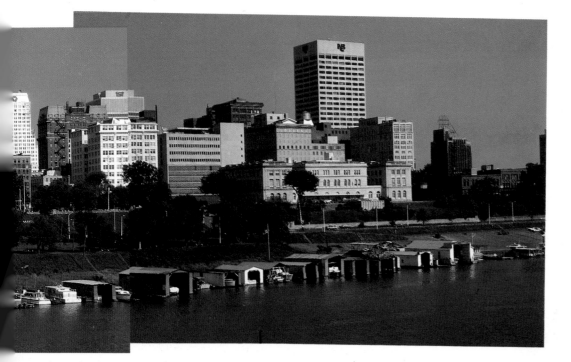

Capturing Movement

In this demonstration I wanted to show how I utilize a photograph of a moving object as reference material for a painting. I deliberately used a slow shutter speed to shoot this carousel horse in motion. The result was a blurred image. Then I shot the scene while the carousel was stationary to capture the rich detail of the horse and its trappings because I planned to paint the scene in its sharpest detail, then use a special technique to blur the image.

Sketch. Notice that my pencil sketch was taken from the sharper photograph and it shows a fair amount of detail. I blocked in the rest of the scene rather hurriedly because I wanted the finished painting to retain as much spontaneity as possible, since it depicts a moving subject. I purposely eliminated a great deal of background detail, then painted the background fully before attempting to paint the horse itself. By painting the surrounding area totally, I can better control the background density in a way that will best relate to the focal point or the subject itself.

Colors. I used Prussian blue and Van Dyke brown for the darker details and shadows, a lot of cadmium yellow and cadmium red in the harness, Winsor blue and Prussian blue in the saddle area, and additional colors such as brown madder, cerulean blue, olive green, and yellow ochre for the various trappings.

Effect of Motion. After I completed the entire painting in sharp-focus detail, I dipped a brush in clear water and began sweeping it lightly across the painting with horizontal strokes, subtly blurring the distinct edges. However, I stopped short of blurring the image to the degree shown in the reference photograph—I wanted more detail to remain than that would have allowed. (Incidentally, another technique for blurring or softening the edges in painting is to spray water from a spray mist bottle onto the painted surface, wetting it only enough to enable one to pick up the board and tilt it forward and back, left and right, loosening the pigment and allowing it to "float." The result is a blurred, impressionistic look that is very satisfying.

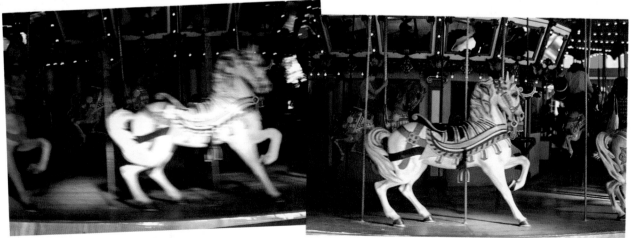

SLOW SHUTTER BLURS ACTION AND IMPLIES MOTION

FAST SHUTTER STOPS MOTION

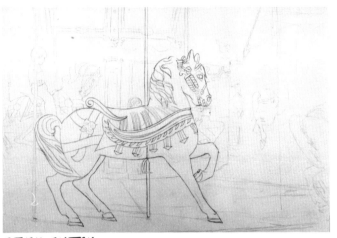

PENCIL SKETCH

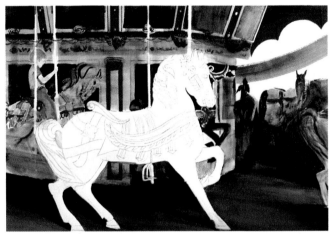

INTERMEDIATE STAGE

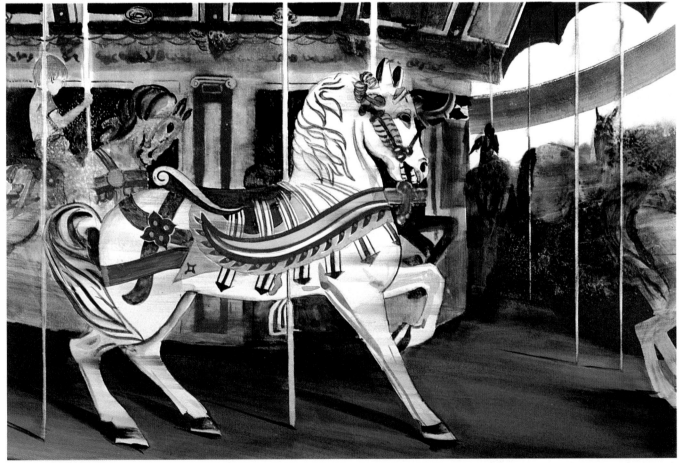

FINISHED PAINTING

"THE CAROUSEL"

Arresting Movement

Wildlife is very difficult to photograph and usually requires special equipment and more time than most artists can spare. For this reason, I used a photograph from the Sierra Club for this demonstration. The obvious advantage of any photo of wildlife over a sketch is that using the photograph lets you freeze the movement of a living, dynamic shape. Then you can return to the studio and study it at leisure later.

Sketches. In this case, the photograph depicts three eagles perched atop a nesting area. I chose to paint the bird on the left, and began by drawing it in a wooded setting. As I have already noted, I used the Sierra Club photograph as the basis for a rough pencil sketch to establish tone and detail. Since I knew I needed something for the eagle to rest on, and also for reasons of composition and design, I also drew a tree. I created this separate sketch of the tree from memory in order to get a feeling for the elements that will appear in the composition. The tree was actually a composite of the many trees I have seen, remembered, and photographed in the past. My intention was to create a heavily textured background so that the eagle would stand out against the darkness even more distinctly. Of course, my final painting, *Freedom*, combines the sketch of the tree with the rough sketch of the eagle for the finished wildlife painting.

Procedure. I used an underpainting of sap green for the wooded background. Sap green is a staining color and cannot be removed, and so I was careful while blocking in not to get any in the area of the eagle. I then worked a mixture of Prussian blue and Van Dyke brown over the sap green underpainting, and made the leaves sap green painted over a Prussian blue and Van Dyke brown wash. The eagle is a combination of yellow ochre and burnt umber, with burnt sienna and a Prussian blue-Van Dyke brown mixture for the wings and darker areas of the body.

 Notice that I have changed the entire color palette of this painting, darkening the background and warming the eagle's colors so that this magnificent bird could be seen in all its strength and beauty.

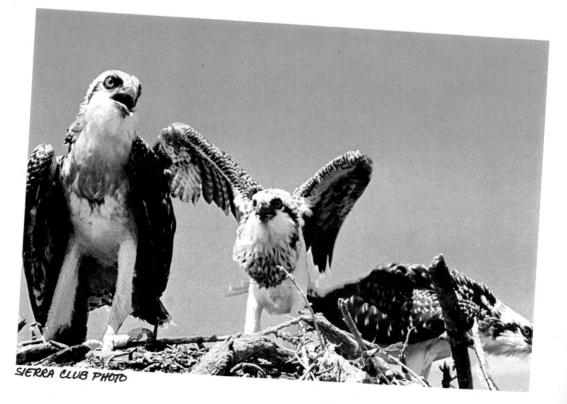

SIERRA CLUB PHOTO

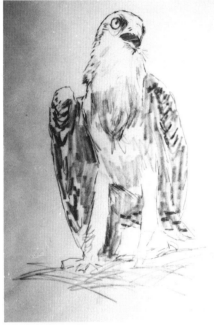

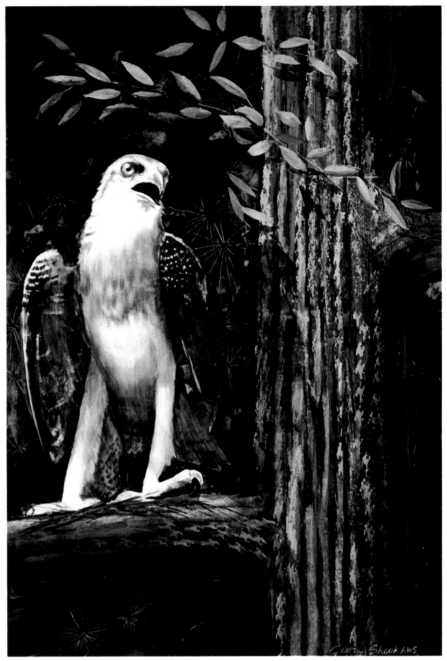

PENCIL SKETCHES FINISHED PAINTING "FREEDOM"

Two Photos, One Painting

Here I wanted to create a floral painting from my photographic reference material. By consulting my slide reference library, I located two photographs that I felt would be useful. The first slide was of daisies in a terracotta vase. The fullness of the blossoms offered good possibilities. The other image was also of daisies, in a clear glass vase this time, and I especially liked the way the sunlight silhouetted the flowers and cast shadows across the edge of the window frame.

I began by making separate sketches since my original intention was to do two separate paintings. But on second thought, I realized that a single, strong painting could be done from this reference material, so I combined the images into one sketch.

Procedure. The sketch is simple because I intended to do most of my drawing with the paintbrush. First I wet the window area, especially the panes, and floated in a mixture of Prussian blue and Van Dyke brown to get a dark, background. The brick was painted with brown madder and burnt sienna, while the shadow detailing was done with Prussian blue and Van Dyke brown. At this point I used Maskoid, a resist material, to block out the daisies. I plan to wipe away this rubbery substance later and let the whiteness of the board itself show through as daisy shapes.

Returning to the sill area, I underpainted a mixture of Prussian blue and Van Dyke brown for the shadow, then pulled a brush loaded with burnt sienna across the sill's edge to give a bit of color to that dark area. The final stages included applying burnt sienna as an underpainting for the pottery vase, and dragging some raw sienna into it, and creating a shadow mixture from Prussian blue and Van Dyke brown. I used the same mix, but heavier on the Prussian blue, for the flower stems, and added some olive green to it for highlights.

Turning to the flowers themselves, I worked into the white design left by the Maskoid, using opaque white for the petals, then yellow ochre and burnt sienna for the flower centers. For the shadows I used a little Davy's gray mixed with white paint, or in some cases glazed over the white underpainting instead. Finally, I used ultramarine blue for some of the final shadow details.

Summary. This is but another example of using photos creatively, using them for information about shadow details, lighting, and other design elements. The final product, however, is a product of the artist's emotional response. It is not a copied photograph, but rather an original painting.

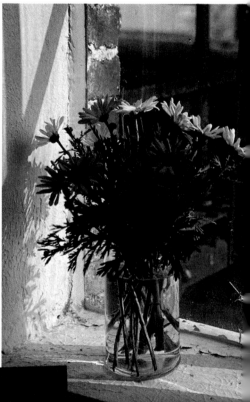

REFERENCE PHOTOS

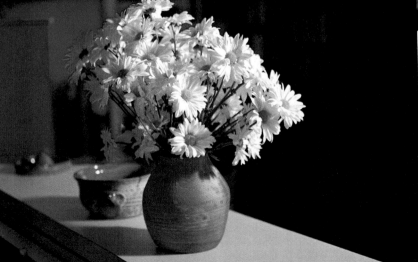

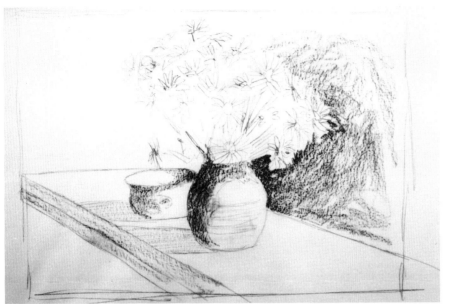

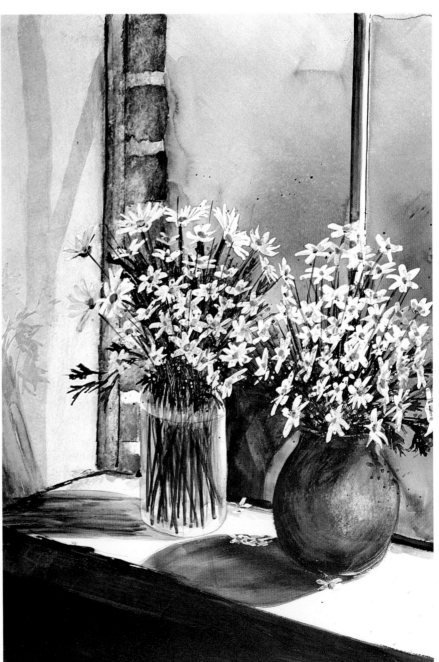

FINISHED PAINTING
"WINDOW DAISIES"

One Photo, Two Paintings

My purpose in this exercise is to create two different character studies from a single photograph. I began with a photograph of an old hermit-like individual standing in front of his house. I decided to eliminate the extraneous material in the photograph and concentrate only on the character of the individual, using the sketches to define and bring out the feelings I had in response to this character.

Procedure: Hermit. In the first painting, *Hermit*, I used the pencil drawing as an integral part of the painting. That is, I vignetted the color so that the pencil study remained visible on the surface of the board, thereby becoming a part of the finished image. For this reason, I did a more detailed drawing than I normally do for character studies.

After sketching the man, I began to apply washes of watercolor over the background to deaden some of the whiteness of the board. In this case I used Davy's gray, although sometimes I use what I call "palette gray," which is a combination of several colors that happen to be on the palette at the time, mixed into a neutral gray.

I blocked in the basic shape of the hat using a mixture of burnt sienna and burnt umber, with a small amount of ultramarine blue, then I used

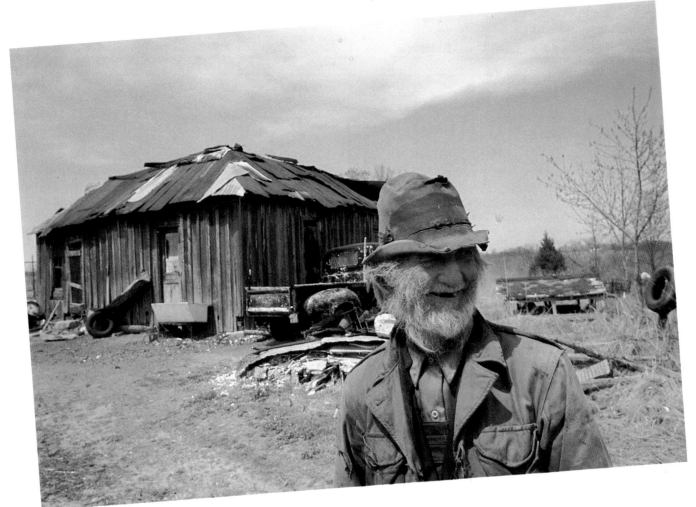

REFERENCE PHOTO

Prussian blue and Van Dyke brown for the shadow detail of the hat. The face was done with cadmium red, very diluted and mixed with burnt umber. The red must be used carefully, since it is a staining color and cannot be removed from the board. However, I felt that an overwash of this color was perfect for capturing some of this old man's rugged character. I also added tinges of burnt sienna to the skin.

I handled the hair somewhat differently, using a drybrush technique to lay down a mixture of Prussian blue and Van Dyke brown. I also pulled some burnt sienna into the color to serve as a connection with the burnt sienna shade in the hat. The overall effect is a somewhat warm tone. Notice that there is a washed-out area on the beard and right side of the face. I achieved this effect by using a sponge and clear water to lift out some of the pigment, leaving a diminished, diluted color in that area. I feel that the effect lends a sort of ephemeral, fleeting feeling to this character study.

I completed the painting using Prussian blue and Van Dyke brown for the shadow detail on the nose and mouth, with Winsor blue for the eyes. The delicate shadow cast by the brim of the hat is burnt sienna and cerulean blue. It is an excellent enhancer for the warm skin tones on the face. Finally, I added detail to the hat by using the edge and tip of a wet brush to remove a great deal of pigment, then I blotted the area with a dry paper towel.

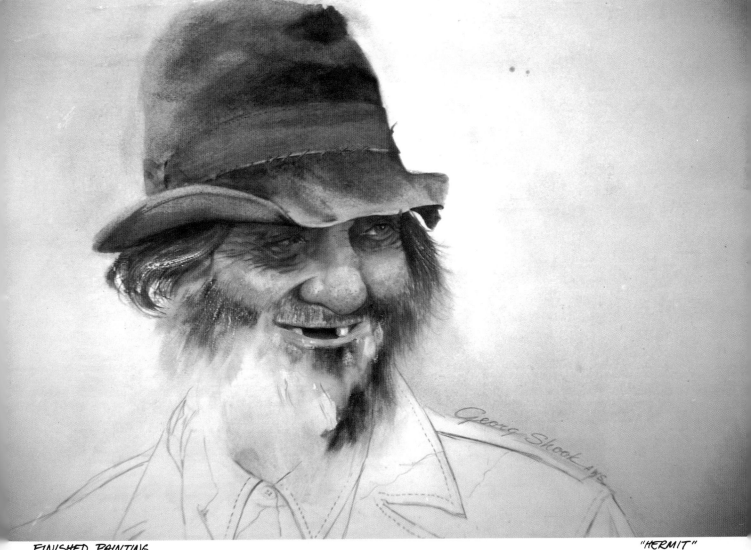

FINISHED PAINTING

"HERMIT"

Procedure: Mountain Man. The second painting was made with a reversed image of the same photograph I used to paint *Hermit.* I feel that *Mountain Man* creates a slightly different mood than *Hermit,* suggesting two separate, though similar, individuals. Again I executed a fairly detailed pencil drawing, but this time I used a different color palette. I blocked in the background with a dark shadow mixture of Prussian blue, Van Dyke brown, and burnt sienna, in some areas pulling out a little pure burnt sienna for added emphasis. Then, after the area dried, I flicked droplets of water onto the surface, let them stand a minute, then wiped them away, lifting some pigment to create a stippled effect. I felt that this highlight offered additional texture to the background.

The hat was painted by blocking in some burnt sienna then blotting it for texture. Then I used a combination of Prussian blue and Van Dyke brown to create shadow and detail on it. I used a diluted mix of these colors for a delicate, transparent shadow on the side of the hat, and used a heavier concentration of the same mixture on the hat brim and felt band. I used cadmium red and burnt umber to paint the skin, cerulean blue for the eyes, and Prussian blue and Van Dyke brown for the beard, pulling a wet sponge through the mixture to create the look of graying hair.

The coat is an underwash of burnt sienna, with a combination of Prussian blue and Van Dyke brown for the shadow details. The shirt is cerulean blue, also with Prussian blue and Van Dyke brown for detail. Finally, I pulled in some very diluted Prussian blue and burnt sienna to darken the white board on the left, then I created a strong shadow on the face—stronger than the shadow in *Hermit*—with a mixture of Prussian blue and Van Dyke brown.

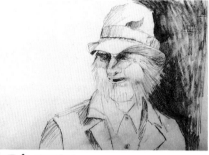

INITIAL SKETCH

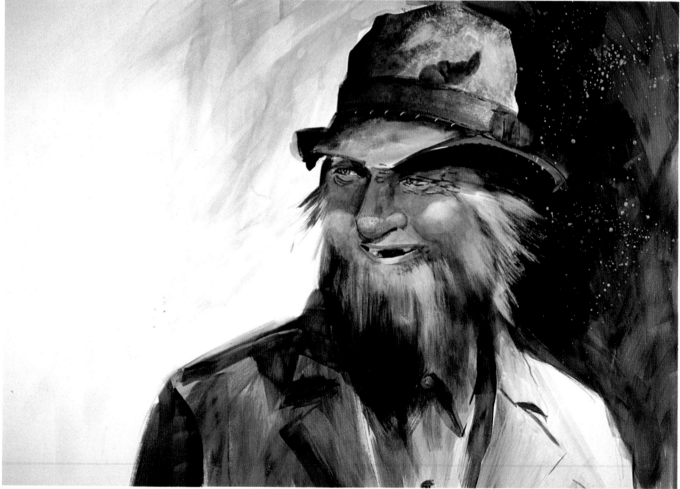

FINISHED PAINTING

"MOUNTAIN MAN"

78

Creating an Abstraction

Sometimes a realistic image can provide the nucleus of an idea for an abstract painting. For example, occasionally I'll throw a slide out of focus in the projector in order to eliminate the literal reference qualities and leave only abstract color and design values. Even without blurring the object, you can study its abstract shape or design.

Each of the three photographs shown here can form the basis for an abstract painting. The close-up of the white flower with its yellow center has abstract shapes and designs within its structure that can be further developed. The oak leaf, with its bright oranges against the dark greens and the colorful flashes of light behind the leaf itself, has a potential for another abstraction. And the shape of the spider web entangled in the rosebush plus the darks and lights of the scene also have potential for becoming an abstract painting.

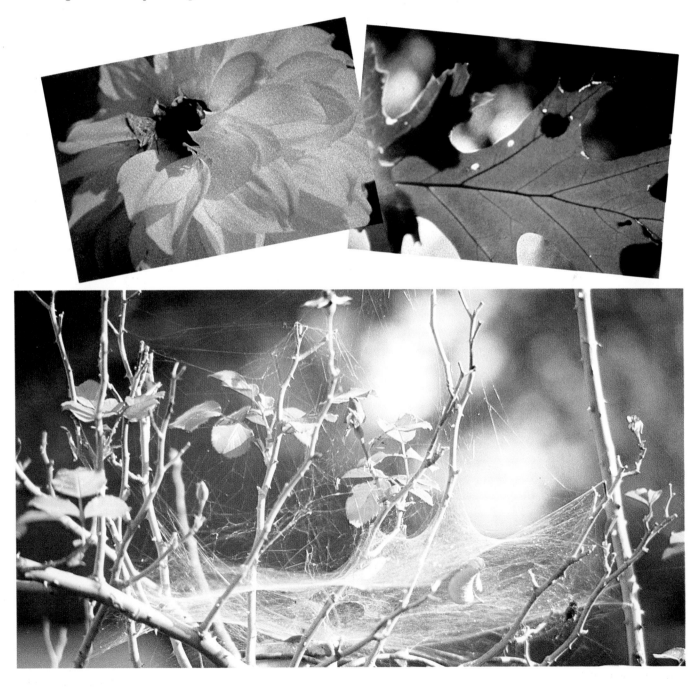

In making an abstraction from a photograph, the idea again is not to copy the blurred image, but to feel the values, shapes, patterns, color, and overall form and translate that overall vision into an abstract work of art.

Mod Pods. Mod Pods is an abstract painting of lily pads, taken from a scene that struck me when I first saw the pods growing from among huge pads lying on dark green water. While this is obviously a literal image, it was presented to me as an abstract shape that I felt I could translate into a painting.

In reducing nature to its simplest terms, I used color to build in the stress and tension I saw in this scene. The basic color mixture for *Mod Pods* is Prussian blue, Van Dyke brown, and burnt sienna, but I added cerulean blue after the painting dried to pull some more life into the scene. A bit of brown madder and cadmium yellow completed the color balance.

FINISHED PAINTING

REFERENCE PHOTO

"MOD PODS"

Building a Strong Composition

I was returning from an exhibition one day, when I noticed this structure beside the road. The thing that attracted me immediately was the utter simplicity of the scene—a basic barn in an open field. Then I noticed the way the red paint peeled away from the wood, and the way the sun cast abstract patterns across the surface of the structure. I knew that I had to paint this scene, but first I walked around the building, taking photographs so that I could later choose the best composition for a painting. I also did a few sketches with a broad pencil to get a a feel for the structure. Even after making reference photographs, I will sometimes do pencil sketches, either on location or back at the studio, to explore the quality and character of the scene, or just to examine the values of light and shadow.

PHOTO 1

Photos and Sketches. At first, I photographed and sketched to establish the scene and suggest a strong design (photo and sketch 1). As I got closer to the structure, however, I noticed the two doors at the end of the barn, the window area in the loft, and the three windows on the side, as well as the huge double doors, propped up by pieces of lumber. I photographed this angle and also made a sketch of it to evaluate the composition and record the abstract planes of light and shadow (photo and sketch 2).

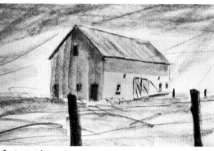

SKETCH 1

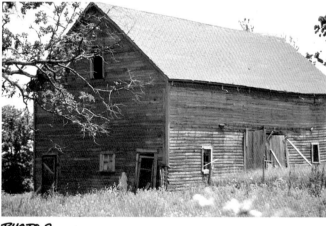

PHOTO 2

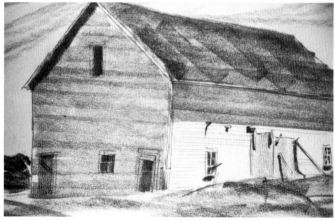

SKETCH 2

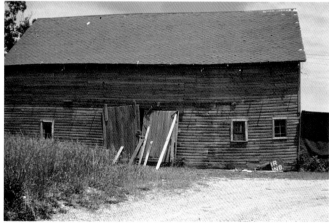

PHOTO 3

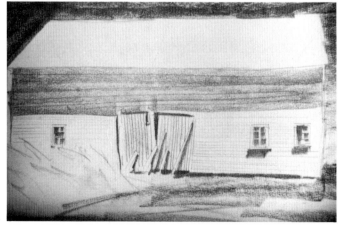

SKETCH 3

I then walked around to the side of the structure and found it to be almost two-dimensional in appearance, with the propped-up doors and asymmetrical windows creating a magnificent design—horizontal siding against vertical doors, with diagonally leaning wood strips above a triangular patch of grass. After I photographed and sketched this basic view (photo and sketch 3), I then sketched it and included a piece of farm machinery that was actually located in an adjoining field (photo and sketch 4, plus photo of plow).

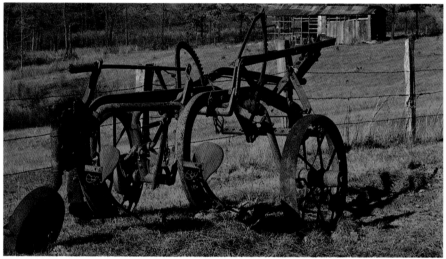

PLOW CLOSEUP

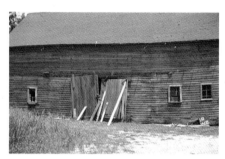

PHOTO 4

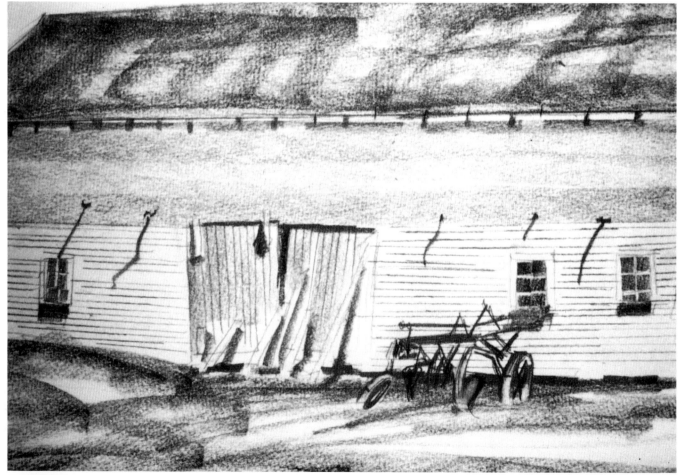

SKETCH 4

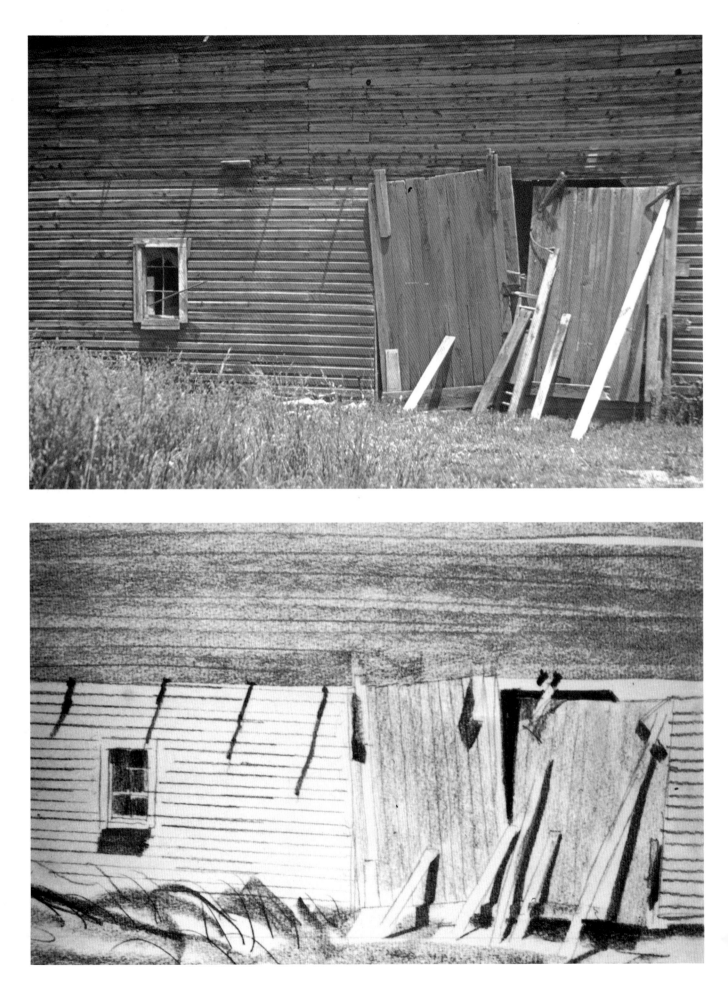

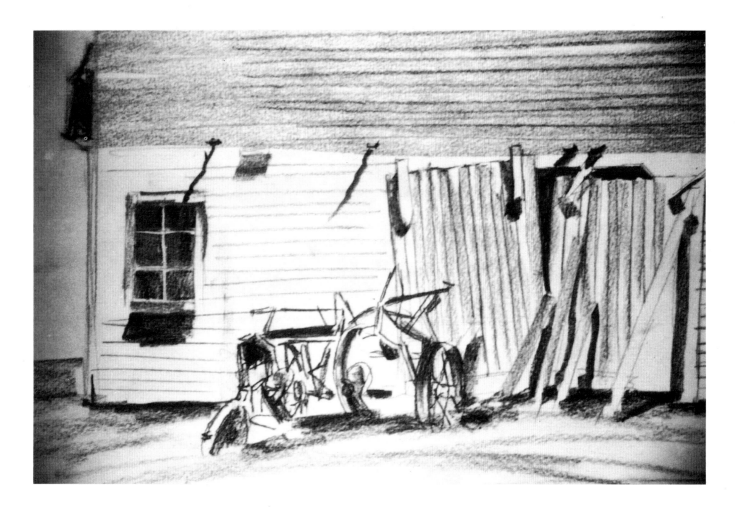

I even moved in closer and did photographs and sketches in which the ends of the barn, as well as the sky, were cut off, leaving only an abstract flat design (photo and sketch 5). After making another sketch of the facade with the turning plow in the foreground (photo and sketch 6), I was ready to return home to the studio.

Evaluating the Material. Back in the studio, the editing process began. While I was pleased with most of my reference material, I found that the first photographs and sketches lacked my emotional response to this scene. Since I felt that the final photograph and sketch (no. 6) contained the best composition, that was the view I decided to paint. This shows how photographing works as a tool for the painter. My instincts overrode the photographic information and caused me to settle on the final sketch as the basis for my painting.

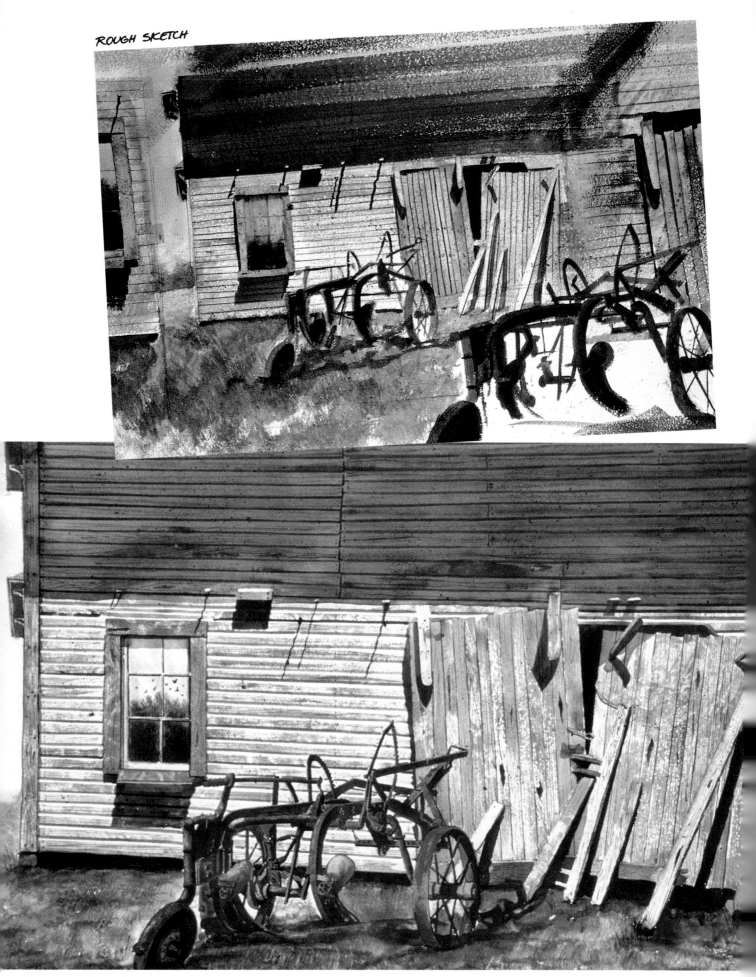

ROUGH SKETCH

"REFLECTIONS OF THE BIRDS"

Rough Sketch. Even though I was using sketch 6, I still had changes to make. I moved the window very close to the end of the structure and included the sky in my painting. I also re-drew the farm machinery between the two doors and lengthened the shadows cast by the overhanging roof. All of these elements were then combined into a rough color study of the scene, in preparation for the painting. Then I thought how nice it would be to have the window reflect birds flying from a clump of trees, so I included that. I also studied the wood texture, exploring the differences between lighted and shadowed wood.

Finished Painting. The finished painting, *Reflection of the Birds,* is a comprehensive rendering of all these elements. I hope that my compositional changes convey my feelings about this subject. For example, the bit of sky was intended as an escape for the viewer's eye, while the reflections of the birds added activity to the scene. The warmth of the rusty farm machinery and its shadows, as well as the propped-up doors, express the rugged character of the structure. I hope my painting conveys the strong feelings I had for the scene.

Additional Example. Later I used photograph and sketch 5 to create a second painting of the subject. This time I made even more changes. For example, I exaggerated the size of the door in relation to the windows, and I painted the doors open to reveal a window on the opposite wall. I also changed the siding from horizontal to vertical board and batten, and, of course, changed the original red color to gray. This painting is entitled *The Little Windows.*

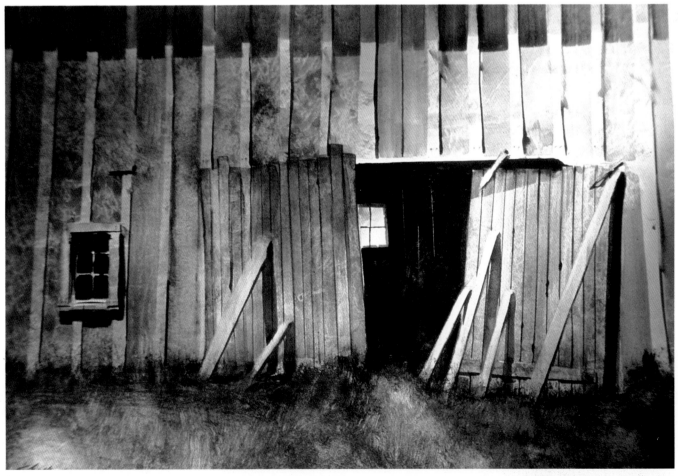

"THE LITTLE WINDOWS"

Working in a Series

During the same field trip that resulted in the painting *Reflection of the Birds*, I also encountered this majestic structure. The first thing I noticed when I saw this barn was the contrast between the old cedar shake roof and the layers of new tin that had been added at the roofline. Naturally I stopped and began walking around the old structure, simply awed by its sheer size and majesty. The brilliance of the sun reflecting off the tin gave the whole affair a rather glorious appearance.

Photos and Sketches. My first photograph, of the side of the structure, clearly shows the newly added tin. I also did a rough sketch of this view to consider a painting based on the contrast between the new white tin and the dark roof (see photo and sketch 1). But I felt that a profile view would not make an attractive painting, so I moved counter-clockwise to a three-quarter frontal view. I took a photograph then did a sketch in which I exaggerated the angle and added some fence posts (photo and sketch 2). I also contrasted the rusty metal on the barn front with the lighter wood.

Then I again moved around the building to photograph a straight-on view of the front of the barn (photo 3). The photograph has a rather abstract look about it, with the triangular roof and the horizontal and vertical stripes of wood and tin, broken by numerous squares and rectangles. My sketch gave consideration to this attractive abstract design, and I added trees and a hazy sky to the rough rendering (sketch 3). After moving around to the other side to photograph another three-quarter view, I took a photograph and made a pencil study, adding values of contrast between the white roof and the horizontal and vertical movement of the tin and wood on the barn's front facade (photo and sketch 4). Then I moved closer and considered the extended shadows of this particular angle (photo 5). In my sketch I added a cloudy sky, and the thought occurred to me that a dark sky might even enhance the contrast between the new white tin and the sky (sketch 5).

The final photograph and sketch (no. 6) is almost a profile of the other side of the structure, with its bright sunlight fairly glistening off the tin roof. My sketch places the barn at a greater distance than the photo, and I added a fence row and trees to the scene.

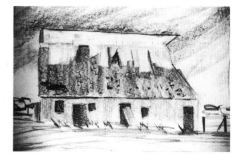

SKETCH 1

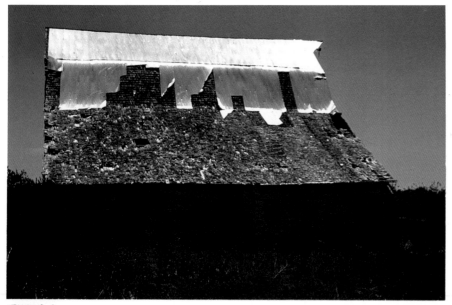

PHOTO 1

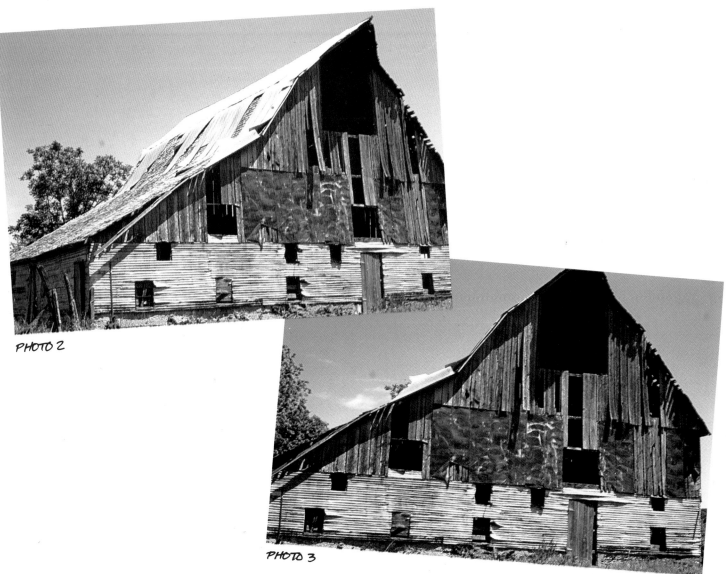

PHOTO 2

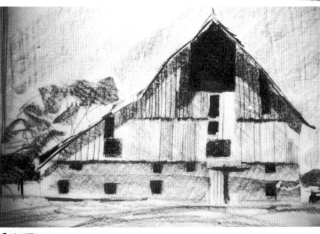

PHOTO 3

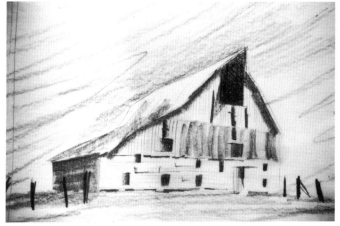

SKETCH 2

SKETCH 3

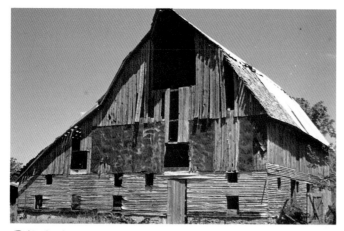

PHOTO 4

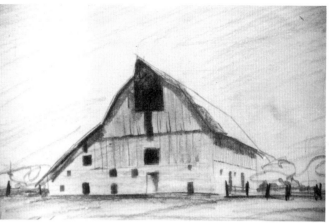

SKETCH 4

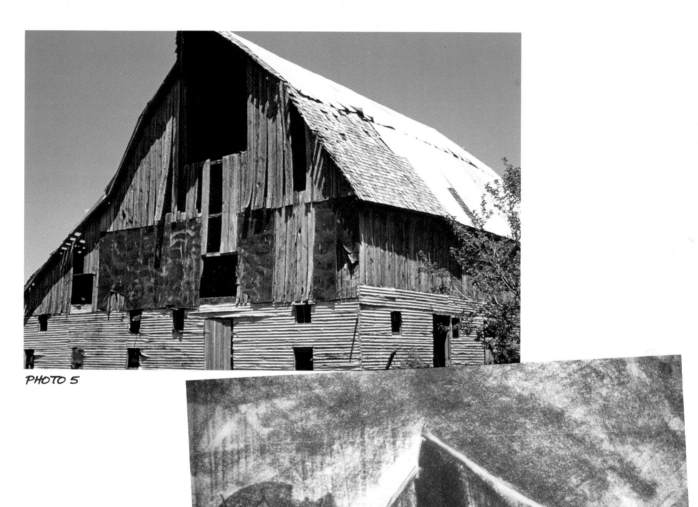

PHOTO 5

SKETCH 5

90

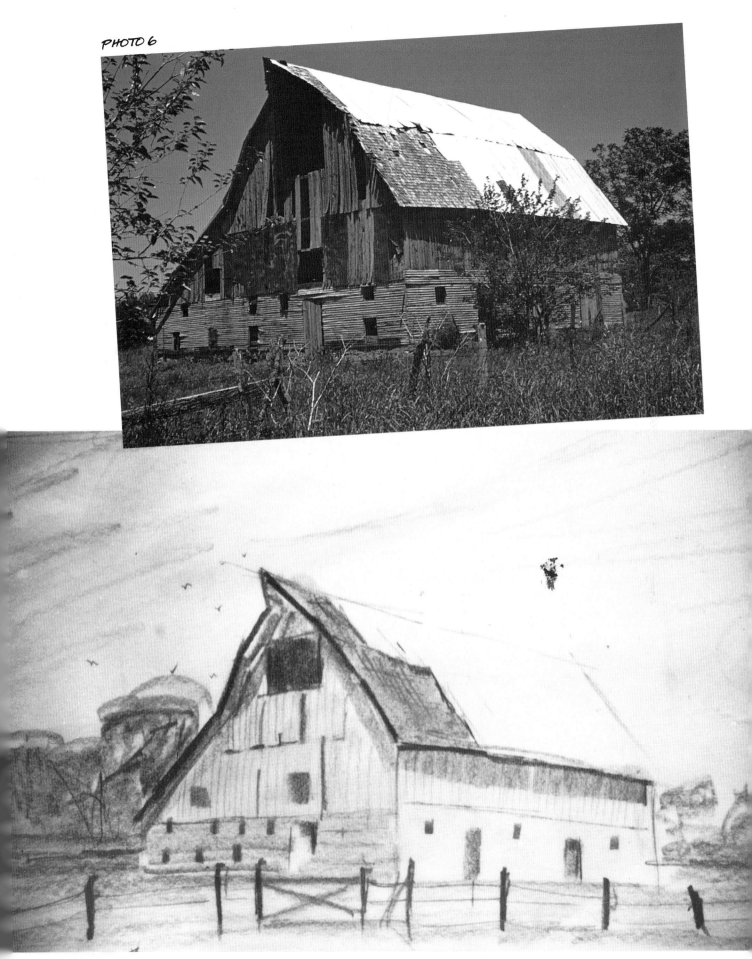

PHOTO 6

SKETCH 6

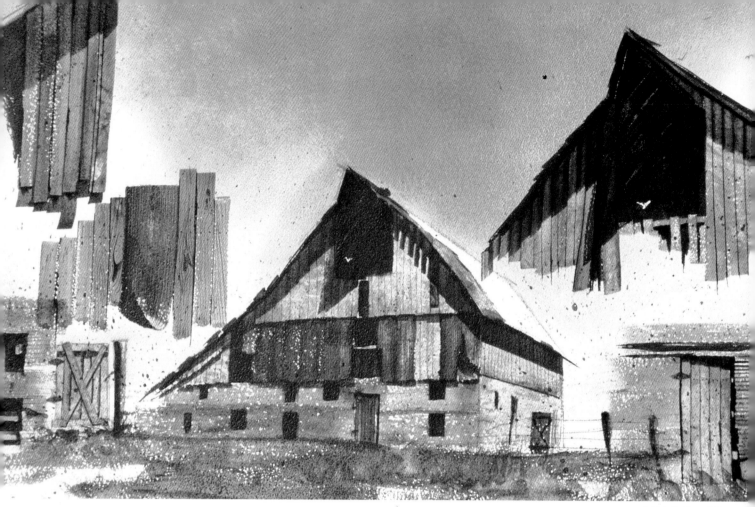

COLOR STUDY

Color Study. Prior to executing my first painting, I did a color study of elements of the barn, especially of the loft area and the shadow cast by the roof overhang. I also explored the texture of the wood in this color study, my final consideration before beginning the paintings.

Colors. The colors used in the *New Tin* series are the same for all paintings: the sky is Winsor blue and Davy's gray; the roof wood is Davy's gray mixed with burnt sienna and cerulean blue; and the rusty metal is burnt sienna and Winsor blue with a little bit of Davy's gray and Van Dyke brown. The dark shadows are mixes of Prussian blue and Van Dyke brown, while the lighter shadows are a more diluted mixture of the same colors.

Paintings. The first painting I completed was called *White Pigeon*, a title inspired by the birds that were flying in and out of the loft as I explored the structure. *White Pigeon* was drawn from photo and sketch 4, but I added a see-through area to the loft to provide an escape for the eye. I also created a stormy sky with cumulus clouds floating in the background for added drama.

Another successful painting was a three-quarter view entitled *New Tin*. It was based on photo and sketch 2 and appeared on the jacket and in the gallery of my first book, *Sharp Focus Water Painting*. This painting was also a large factor in my acceptance into the American Watercolor Society. I wanted *New Tin* to depict the majesty of this beautiful, old structure. And I especially wanted to stress the contrasts: a silvery, new tin roof against a bright blue sky; the shingle roof and shadows cast by the overhang balanced against the lightly bleached wood on the front facade; the rusty tin against the steel plating, broken by interesting rectangles and squares; and finally, the subtle nuances of light and shadow giving the essence of life to this glorious structure.

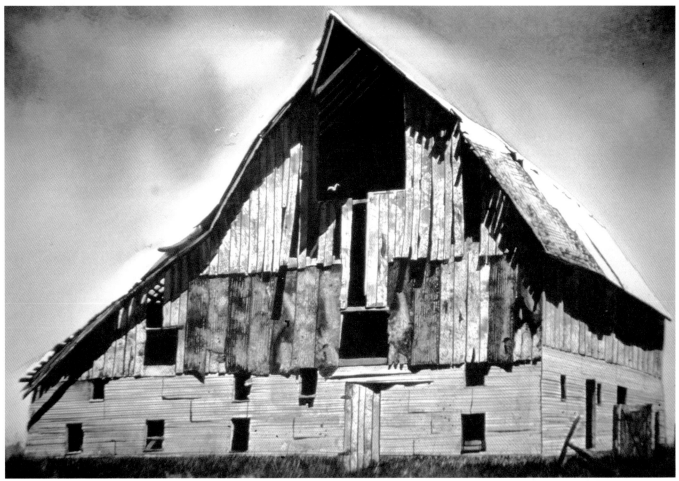

"WHITE PIGEON"

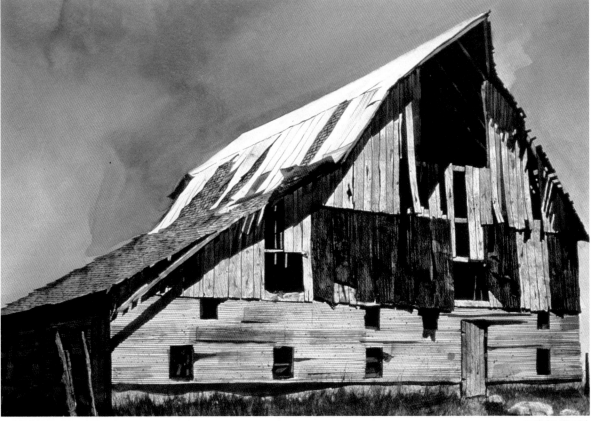

"NEW TIN"

The third painting done from this series was titled *Rock City Barn*, and was based on photo and sketch 6. Ever since I saw a similar barn with a "Rock City" sign painted on its roof, I was fascinated by the idea. It seems that years ago the Rock City people traveled the country offering to paint a farmer's barn for free if they were also given permission to paint a sign on the side or roof. Recently, the Rock City Company conducted a nationwide competition for artists to submit paintings of barns with "Rock City" signs on them. Since I had seen such a structure, I used the *New Tin* series as reference material to paint such a barn. This is my entry and I am proud to say that it won the top award.

Another painting to emerge from this set of reference photographs is *The Cattle Ramp*, also done from photo and sketch 6. For this painting, I imagined a cattle-loading ramp in the middle foreground as a contrast to the neutral tones of the building's side. I wanted it to add to the realism of the scene and provide additional contrast to the sunlit roof and rusty tin. In *Cattle Ramp*, my aim was to build strong detail in the front facade of the barn, then diminish the detail while lightening the value toward the rear of the barn. This gives a sort of halo effect to the painting, and emphasizes the beauty of the shapes and contrasts on the front of the structure.

The final painting in this group, taken from photo and sketch 3, is *Aloof Aloft*. The point here was to close in on the loft itself in order to emphasize the beauty of that heavily shadowed triangular peak. A window was added on the opposing wall to allow an escape for the eye of the viewer.

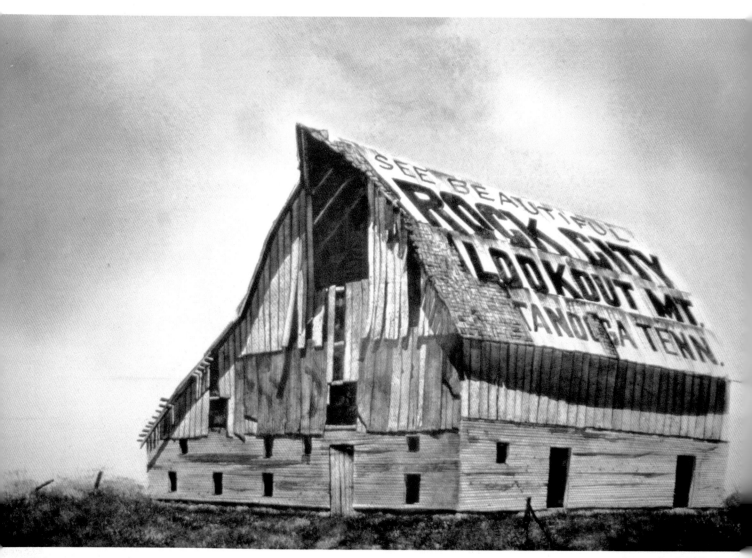

"ROCK CITY BARN"

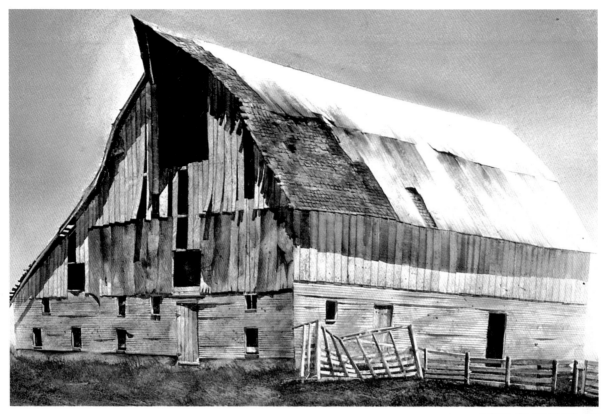

"THE CATTLE RAMP"

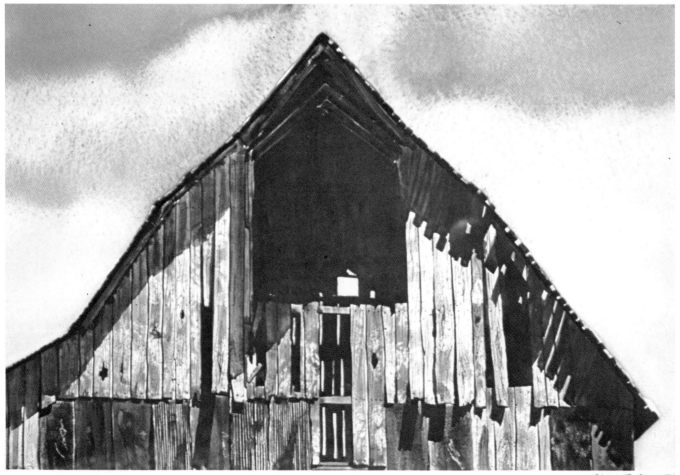

"ALOOF ALOFT"

"BEFORE THE CHASE"

APPLYING THE TECHNIQUES

Beale Street

This is a painting of the world-famous Beale Street in Memphis, Tennessee, looking west from the corner of Third and Beale. In my sketch I depicted the scene as it appeared in the reference photo, but in the painting, I took the liberty of backdating the view to depict the scene before modern streetlamps were added and the buildings were boarded up. I wanted to show the vitality of Beale Street in its prime. To do this, I changed the color of the facades back to what was once their original hue, a combination of burnt sienna, cadmium red, and brown madder, with cadmium yellow and cerulean blue in some window areas. Winsor blue and Davy's gray were combined for the sky treatment, and the streets were made with a combination of Davy's gray and ultramarine blue.

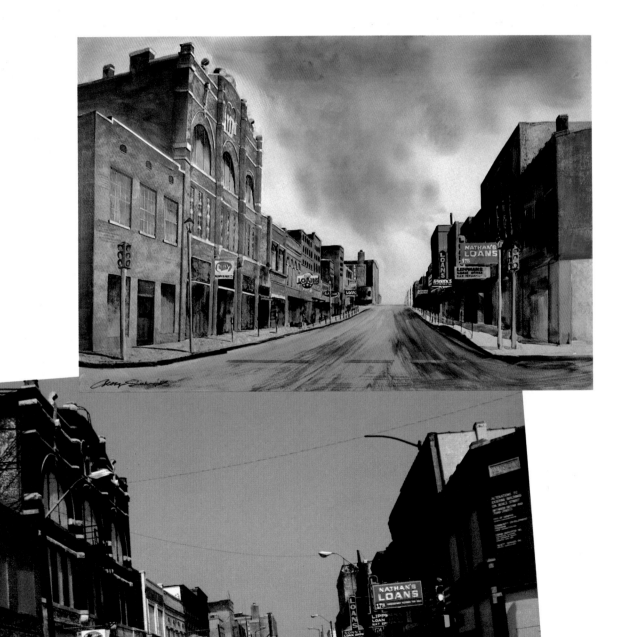

Memphis Skyline

Color photographs, especially slides, often intensify colors unnaturally, and this must be corrected in the final painting. Notice the difference in color between the photograph and the painting. The Mississippi River is not the blue indicated in the reference photo; it is the color in the painting. Another change I made was to add the river museum that was just built on Mud Island. This updates the Memphis skyline to its present appearance. The sky was painted with a combination of Winsor blue and Davy's gray, while the water was done with ultramarine blue and burnt sienna. The skyline itself was painted burnt sienna, Prussian blue, and Van Dyke brown, with olive green and cadmium red used in the trees and structures. The detailing on the bridge was olive green, while the shadow was made with a combination of Prussian blue and Van Dyke brown.

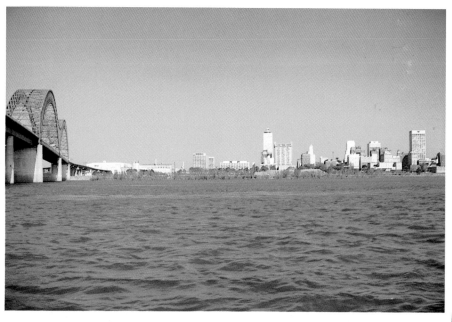

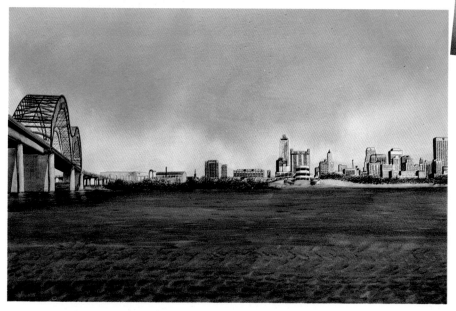

Lee Home

This commissioned painting is a fairly literal interpretation of the reference photograph. The sketch was executed in a very detailed manner, but I took some artistic liberties with the handling of the light and shadow on the structure itself and on the tree foliage in the foreground. By extending the length and increasing the density of the shadow detail, I was better able to convey the imposing character of the structure. The sky was done in cerulean blue. The trees were painted olive green, burnt sienna, Prussian blue, and Van Dyke brown. The facade itself was of Davy's gray and cadmium red with brown madder on the roof. Prussian blue and Van Dyke brown were used for shadow detail.

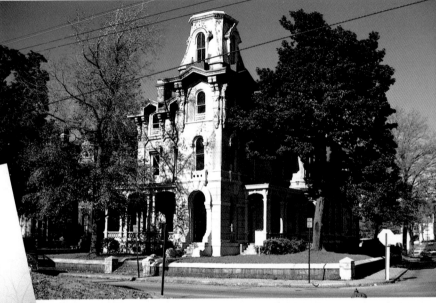

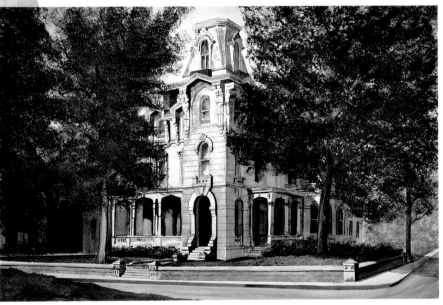

The Upper Room

Although I changed the color value of the photograph to create this painting, I did interpret the composition somewhat literally. Notice that I placed the structure further into the background, eliminated the trees on the left, and extended the depth and intensity of the shadow so that I could bring more sunlight over the front portion of the facade. I used Prussian blue and Van Dyke brown in the background and shadow areas, and olive green in the grasses.

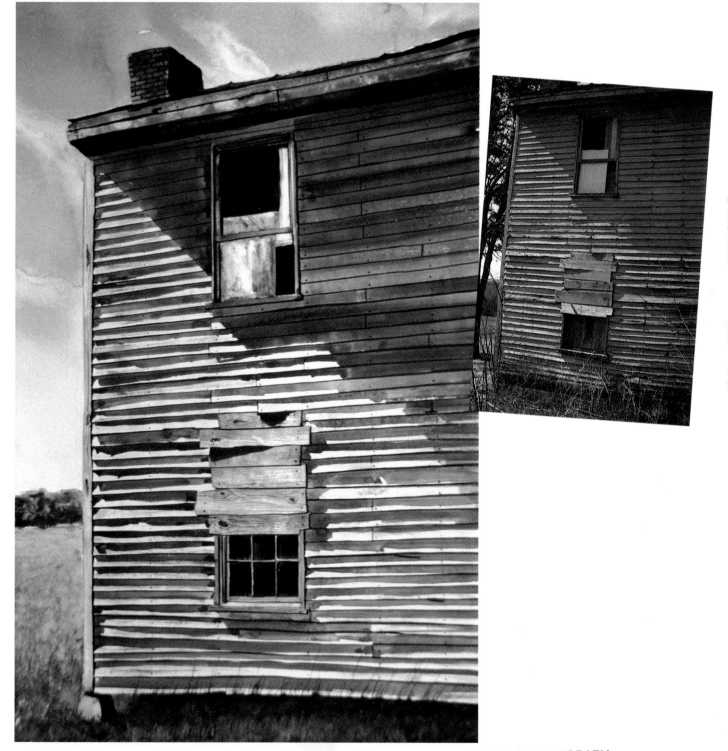

Waller's Place

This is another commissioned piece, and I tried out several points of view before settling on the photograph that I felt offered the best view of the red building. I chose this three-quarter view because it seemed to offer the most dynamic, yet balanced, composition. I painted the sky in Winsor blue with Davy's gray; the red bricks are cadmium red with Prussian blue, Van Dyke brown, and burnt sienna; and I used olive green on the storefront. Ultramarine blue and Davy's gray were used on the streets, and the detail work was Prussian blue, burnt umber, and Van Dyke brown.

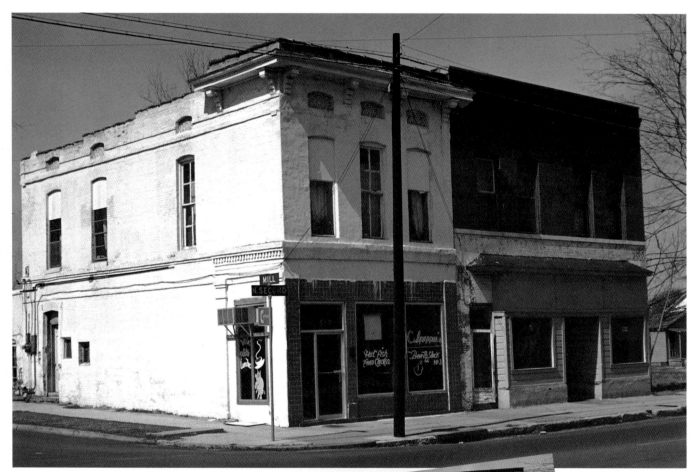

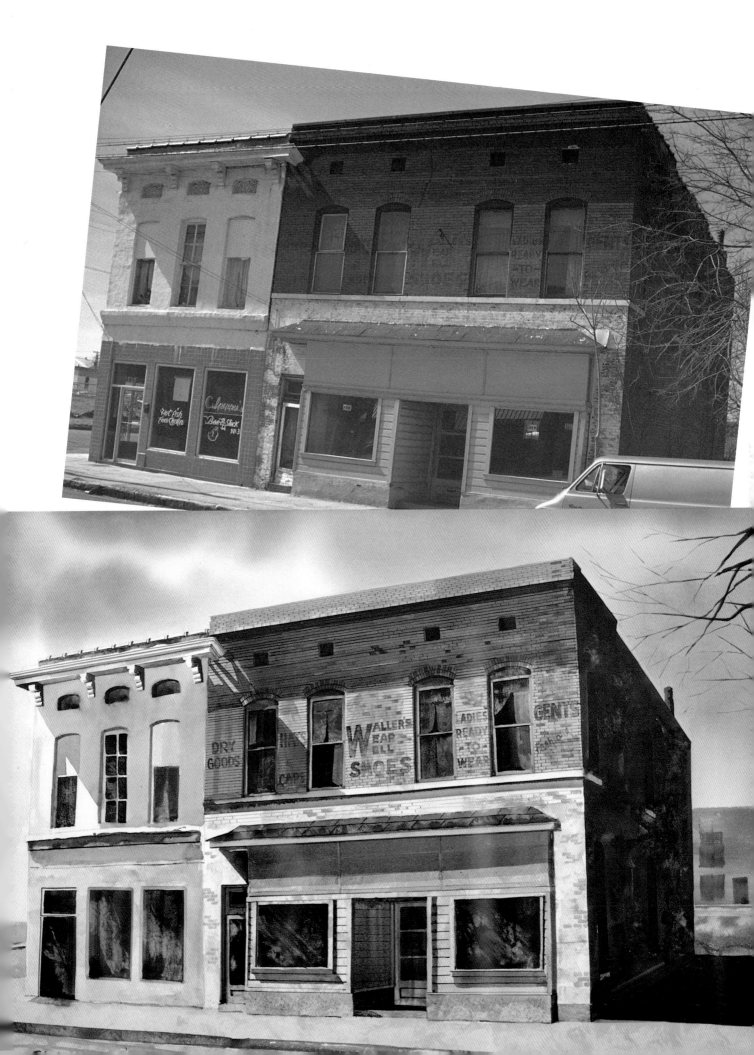

Blue Jumper

I found this old house in middle Tennessee, and I was fascinated by the rear doors, especially the deteriorating whitewash. I first thought of drawing both doors and using the silver cylinders as primary points of entry into the painting, but I found the single door with the mop hanging next to it more intriguing. I actually used all of these reference photographs for compositional considerations, but then flopped the final photograph to give myself a reversed image. It made the painting less literal, and I felt that the linear quality of this particular composition would lend itself better to a left-to-right reading. I then used the coat or jumper, which was hanging over the top of the door, as the primary focal point or point of entry into the painting.

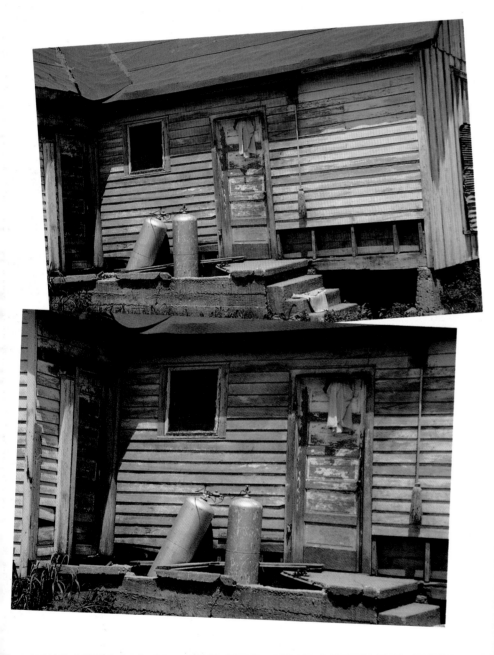

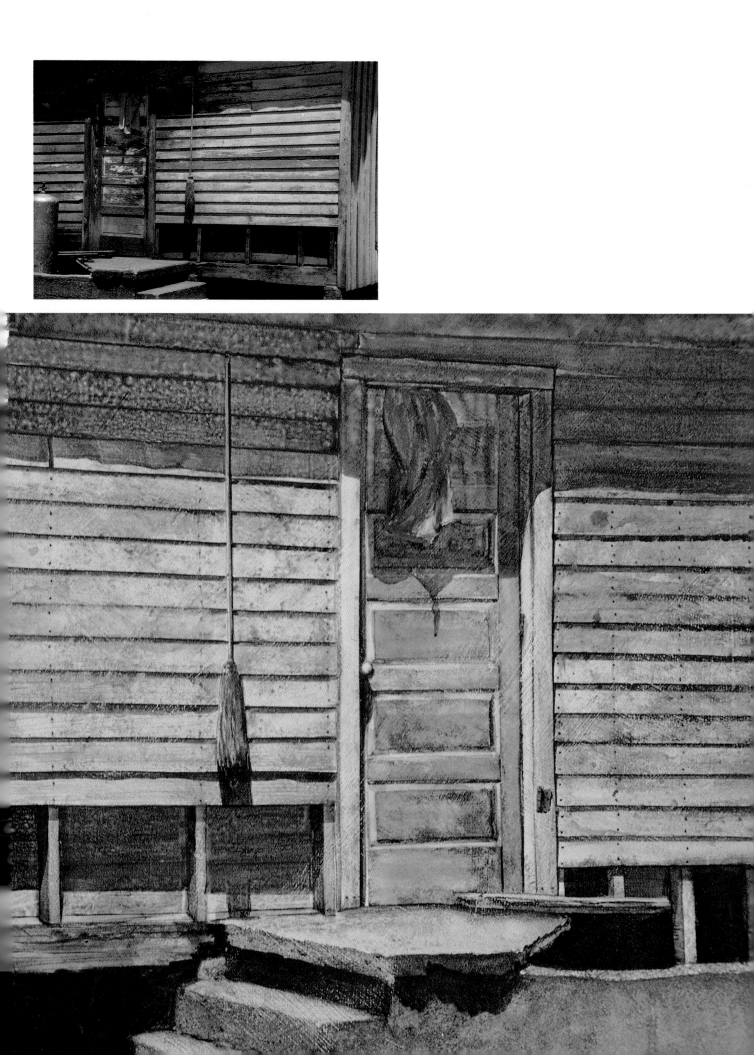

Morning Light

I did the pencil sketch early one morning when the sunlight was casting delicate shadows across the trunk of this tree. In order to refresh my memory of the mood and sunlit feeling of that morning, I later made reference photos of other trees in delicate sunlight and shadow. These gave me greater insight into the lighting and how shadows fall across and around tree trunks and limbs. With the aid of these refreshers, I completed the painting with a mixture of Davy's gray, burnt sienna, Prussian blue, and Van Dyke brown on the trunk, while washing out certain areas for highlights. The grasses were painted olive green, with burnt sienna mixed in, and the shadows were done with a mixture of Prussian blue and Van Dyke brown. The sky is Winsor blue and Davy's gray.

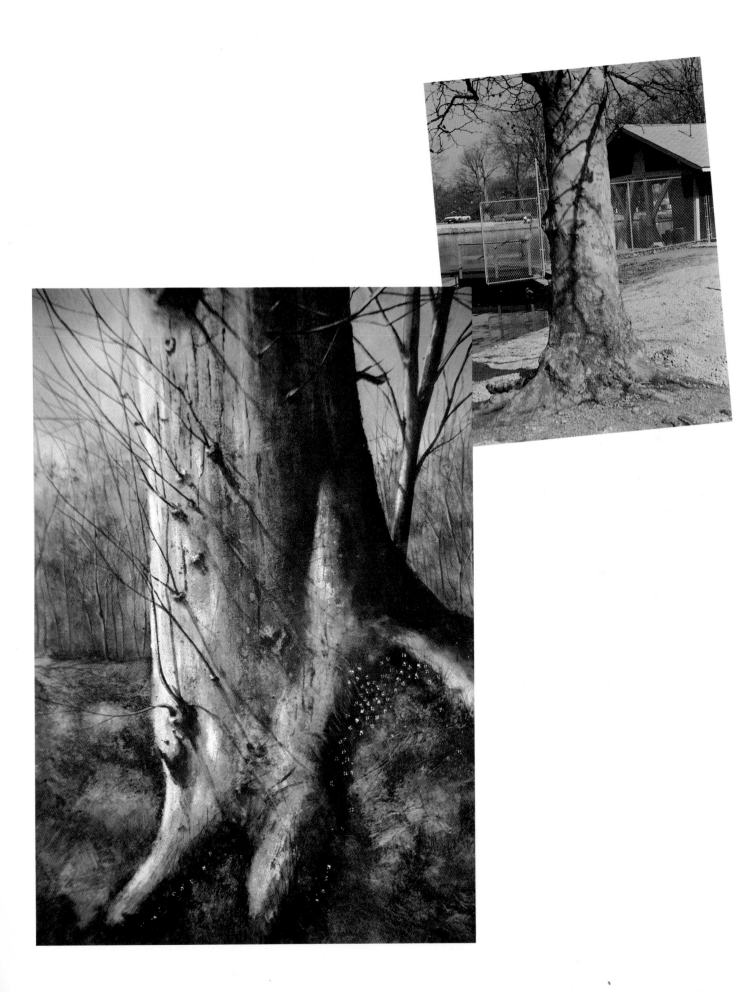

Forsythia

I liked this scene and wanted to paint the forsythia bush, but felt that several changes were called for. I removed the road completely, since I wanted to concentrate on the sunlit fence and bush. Then, after studying the composition, I decided to bring the house further into the painting to serve as a vertical stopgap for the strong horizontal design of the fence. I also eliminated the shadows cast by the tree onto the fence. The grasses were painted burnt sienna and an olive green and ultramarine blue mix; the trees were olive green, Prussian blue, and Van Dyke brown; and the bush was cadmium yellow. The fence was made with Davy's gray, while the detailing was done with Prussian blue and Van Dyke brown.

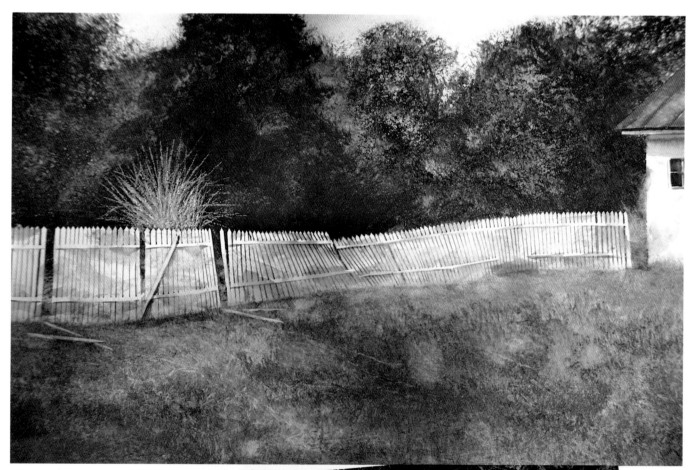

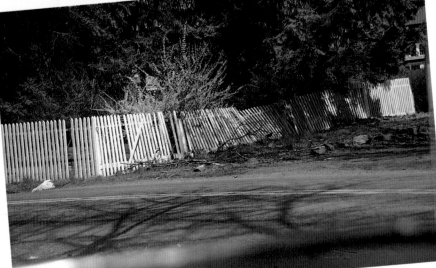

Realtor's Building

Since this was a commissioned painting, I did a somewhat literal interpretation of the actual scene and the reference photographs. In other words, I wanted to depict the building pretty much as it existed, and reference photos are excellent tools for that purpose. The painting utilized Winsor blue and Davy's gray in the sky; cadmium red, burnt sienna, and brown madder in the building; and Prussian blue with Van Dyke brown in the roof. I used olive green in the grasses; brown madder and Van Dyke brown in the trees and branches; with Davy's gray and French ultramarine in the street and parking lot.

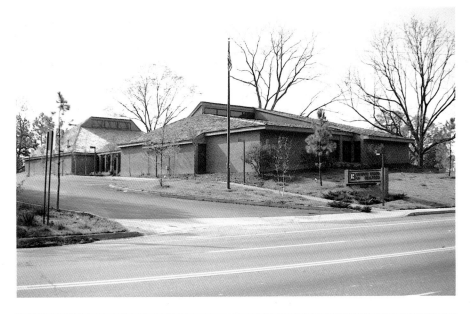

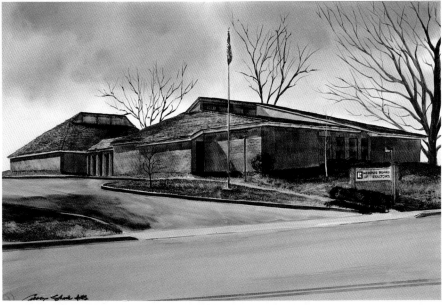

River Traffic

I wanted this painting to capture the feeling of the river traffic that passes Memphis on a regular basis. I took the first photograph from a building adjacent to the Mississippi River in downtown Memphis, hoping that this vantage point would reveal the expanse of this great river. The other photo is a fairly close-up shot of a barge and towboat. I then did a sketch that combines elements of each photo into a unified composition. One of the problems of combining reference photos in this manner is to keep the size references relative to each other. In this case, the barge and towboat should look as if they are located just off the riverbank, near the building. This placement puts them into perspective with the rest of the composition. The final painting was executed using Winsor blue and Davy's gray in the sky; Winsor blue, burnt sienna, and cadmium red in the water; and burnt sienna, Prussian blue, Van Dyke brown, and brown madder in the buildings.

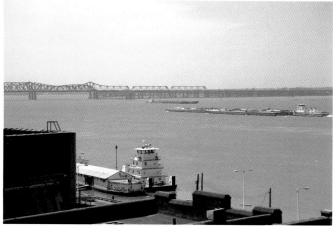

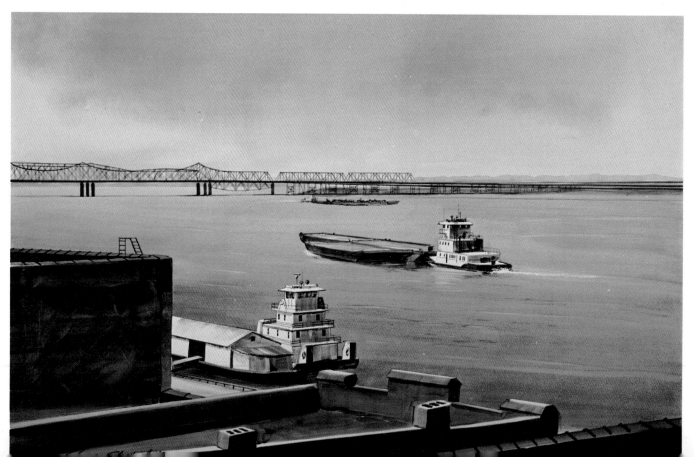

Window Study

This is a fairly literal interpretation of a window area that was located above a sidewalk near my home. The way the window was built into the side of the building, set into a triangular recess, fascinated me. I wanted to capture the feeling of this unique design, but decided to build a more interesting brick area around the window by changing the color value. I used cadmium red, burnt sienna, and burnt umber in the detailing of the bricks in the window area; and Davy's gray on the woodwork, with Prussian blue and Van Dyke brown for the shadow areas. In changing the color values away from the reference photograph, I feel I was able to call greater attention to the uniqueness and beauty of the window structure.

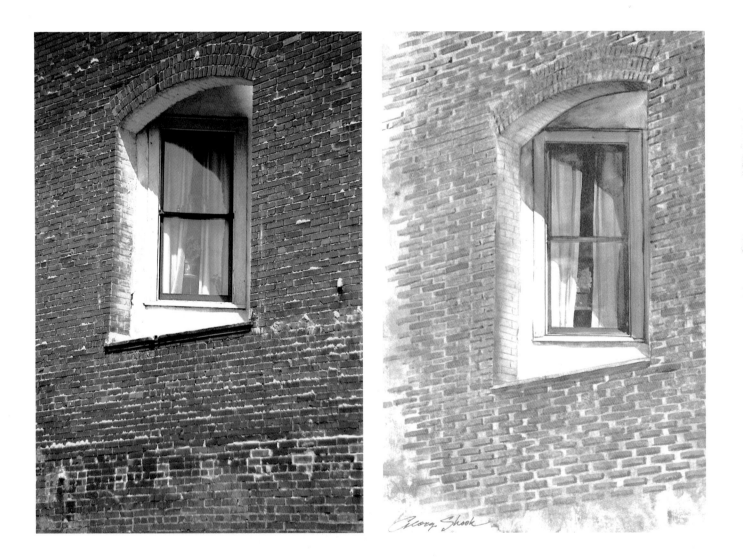

Leaning Gently

I found this barn to be a compelling structure. The character of the wood, the dense shadows, the way the light passed through the opening—all exerted their fascination. Yet as a painting, I felt this scene left something to be desired. I searched around and found another area in which the light passed through an opening in the center of the barn, thus highlighting that gently sloping structure. The slant of the sunlight and shadow down the passageway gave me the idea of slanting the entire structure itself. Davy's gray, Prussian blue, burnt sienna, and cadmium yellow were used for detailing the structure; with cadmium yellow and burnt sienna for the grasses; and cerulean blue for the sky in the background.

Baptismal Bay

I was first attracted to this old church in Mississippi by the incomplete whitewash job on the back outside wall. After returning to my studio with one reference photo, I became more intrigued with the baptismal bay, the protrusion at the rear of the structure, than with the structure itself. I elected to take a painterly approach and render the subject in a loose, sketchy style in order to capture the mood of the scene rather than merely restate the architectural detail. I used cerulean blue and Davy's gray in the sky, burnt sienna and cerulean blue on the roof, with Prussian blue and Van Dyke brown in the window detail and shadows beneath the structure.

Shadow of the Bell

This is a fairly literal interpretation as far as composition and detail go, but I did change the color palette to give a greater sense of depth in the upper right area of the painting. I blended some olive green into the distant treeline to make it more distinct while, on the other hand, I painted the pumpkins in a lower, more subdued key than they actually appeared in the photo. I used an underwash of Davy's gray on the wood, then detailed the logs with burnt umber, Prussian blue, and Van Dyke brown. The pumpkins were done in a cadmium yellow medium, and warmth was added to the wood with a burnt sienna wash. I used olive green for the grasses; and the shadows were a diluted mixture of olive green, Prussian blue, and Van Dyke brown.

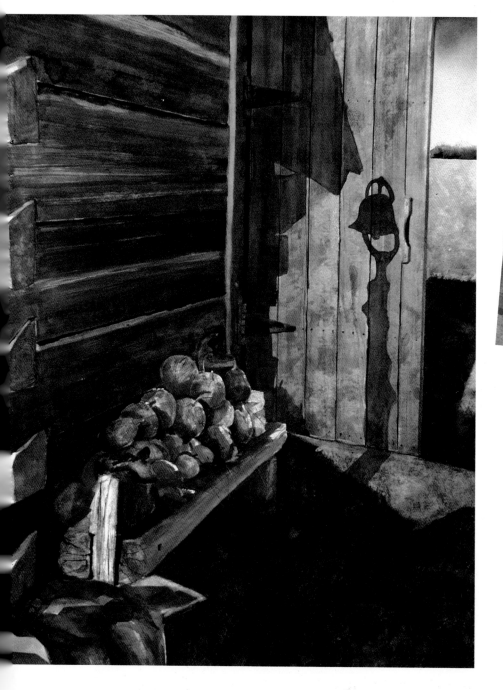

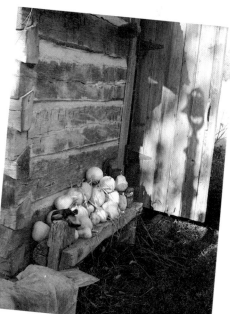

Rags

At first glance this may appear to be a literal interpretation of the photograph, but there are several differences. I extended the format of the storefront and changed the value of the yellow drum in the foreground. I also altered a few elements inside the window to lessen the visual interest in that area. This allowed the eye to concentrate on the barrel and drum in the foreground, the trashcan with rags in it, and the bag of nuts sitting atop that trashcan. These changes offered a more pleasing composition than the photo.

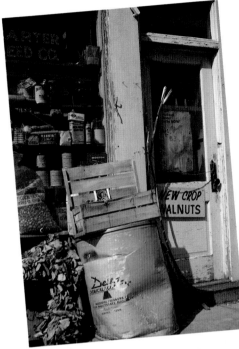

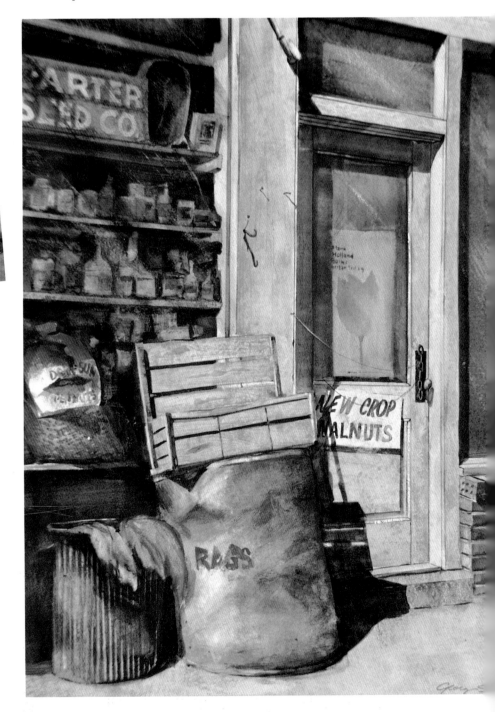

Another Barn

Sometimes I like to use more than one reference photo in order to gain another point of view on the subject. In painting this three-quarter view of a barn, I adapted elements from both reference photos, then decided to enlarge the front facade to fill the frame. That way I could concentrate on the detail of the wood and the opening in the front of the barn as well as the metal roof. Again I made several changes to improve the design of the composition and to direct emphasis to areas that deserve greater viewer attention. I did not make the lower roof area the same color as the photo, nor did I deepen the shadows from the side of the structure as much as they appear in the photo. I also refrained from making the painted wood as intensely colored as it appeared. I used Winsor blue and Davy's gray for the sky, Davy's gray and burnt sienna with cerulean blue on the wood, burnt sienna and Prussian blue on the shadow detail, and painted the grasses olive green and burnt sienna, with ultramarine blue shadow detail.

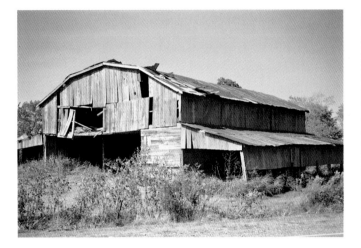 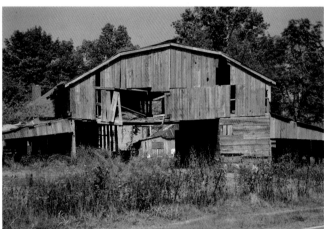

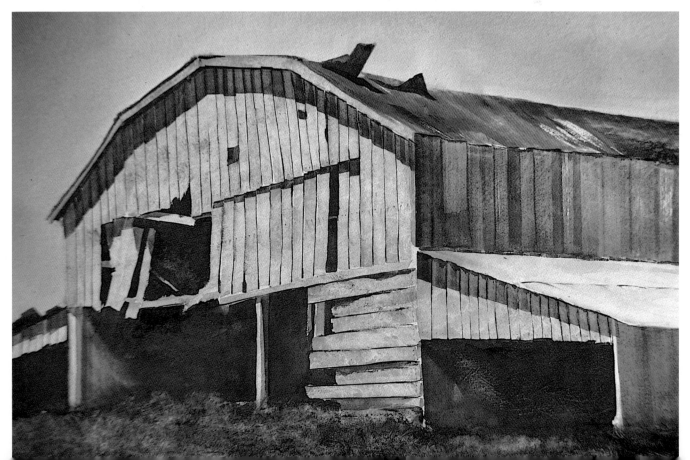

Wicker

I liked the composition of the reference photos here, but I decided to change the color value of the porch, woods, and grasses. I did this because the scene called for a warmer, more comfortable feeling. I used a diluted mixture of Prussian blue and Van Dyke brown for the shadow detail along the rocker and the porch posts, and I used olive green, Prussian blue, and Van Dyke brown for the grasses and evergreens.

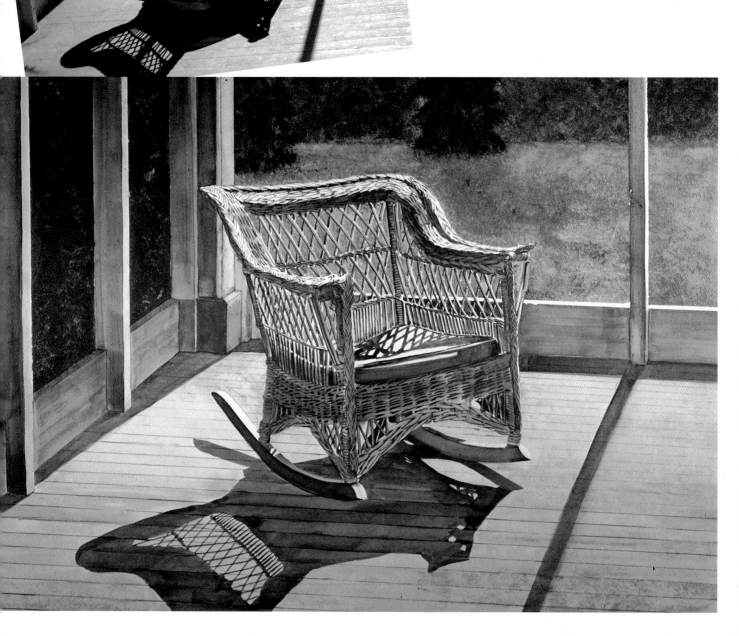

Early Thaw

Although I felt that the reference photograph would lend itself to a finished painting, I did choose to change my painting to a close-up version of the tree in an early winter setting. (I sometimes change the point of reference in a painting to a close-up in order to convey my intimate response to that subject.) I used Davy's gray, burnt sienna, Prussian blue, Van Dyke brown, and ultramarine blue in the trees, with an increase of burnt sienna for the surrounding grasses. I also used burnt sienna and ultramarine blue, as well as Prussian blue and Van Dyke brown for the background branches.

Carter Seed

This is an example of how the mood of a painting can be altered by a change in the color value. I stayed pretty faithful to the reference photos in this case, but eliminated much of the red color from the exterior. I also changed some detail among the bottles and boxes in an attempt to create a stronger design in the window area. I added some depth to the shadow area of the window to strengthen the contrast between the exterior and interior. I used burnt umber, burnt sienna, and cerulean blue for the wood in the painting; with Prussian blue and Van Dyke brown for the shadows. The sidewalk was painted Davy's gray and cerulean blue, the basket was done with yellow ochre, and the signs were made cadmium red medium.

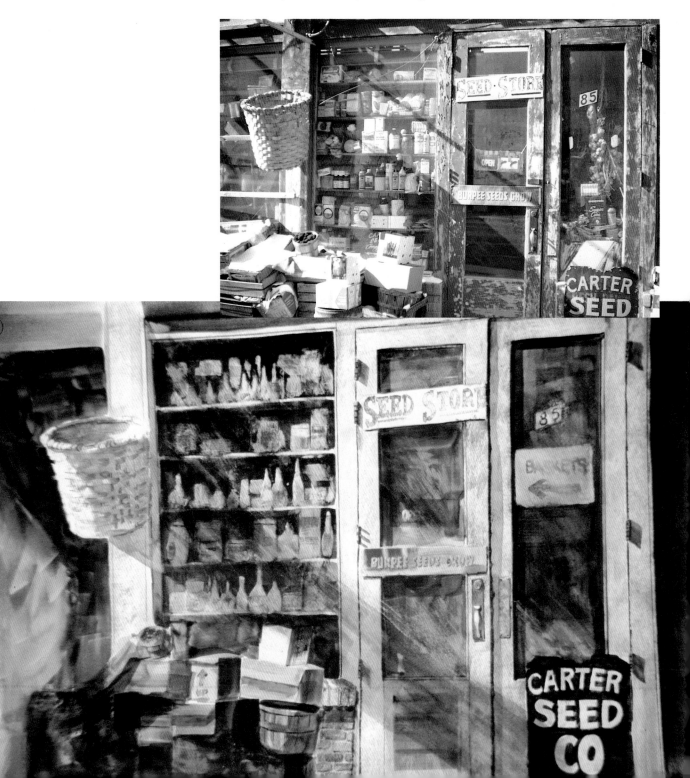

Mansion

This painting was commissioned by the family who lives in this house. I especially like the isolated location and the long road that leads to the house. I painted the house from the viewpoint of the reference photo, but the tree in the foreground bothered me. It was too close to the entranceway and I felt that it competed for attention with the structure itself. So I exercised a bit of poetic license and moved the tree to the right while maintaining the feeling and character of the setting. Interestingly enough, upon seeing the painting, the family was not even aware that the tree was in a new location! I used cadmium red and burnt sienna for the bricks; the roof and front facade is Davy's gray with ultramarine blue shadows; and I used a combination of Prussian blue and Van Dyke brown for the trees, over an underpainting of olive green. The sky is Winsor blue and Davy's gray.

The Gift

This was a commissioned painting to be used by the Phoenix Club as a Christmas card for their Boy's Club. They wanted a winter scene that was related to Christmas, and so I took this reference photograph. However, I made several changes to transform it into what I feel is a better-composed work. For example, I added a second mailbox and showed it open with a package inside it. I also added an evergreen tree to the foreground and placed more evergreens in the background and distant horizon. The sky was painted with Davy's gray; the weedy area was a burnt sienna and burnt umber mixture; and the evergreens were made with Prussian blue and Van Dyke brown. I painted the mailboxes with a combination of Davy's gray and burnt sienna, and painted the bow on the package a cadmium red medium.

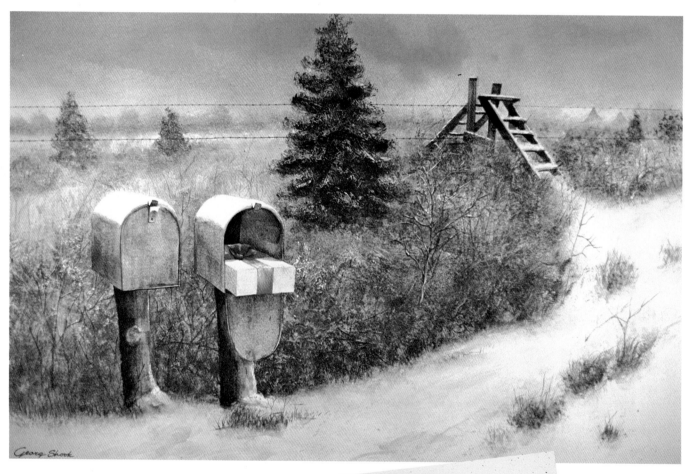

Winter Gray

While I felt that this reference photograph was compositionally pleasing, I decided to strengthen the effect by eliminating the evergreen tree at the left-hand corner of the structure. I wanted to make the scene as desolate, cold, and wintry as possible, and decided to place the structure in the most barren setting I could. A Davy's gray wash was used in the sky, while Prussian blue and Van Dyke brown were used for shadow detail on the structure. I used burnt sienna for the foreground grasses and on the tin alongside the structure.

My Name Is Many Faces

Here is one case where photography is used merely as an inspiration rather than as a source for detailed reference material. The slide of the Indian sparked the thought of painting an Indian in full-feathered headdress and regalia. Since it was the Bicentennial year at the time, I felt that adding a flag to the composition would make a striking statement. It may be of interest to know that this painting was selected by the president of a major Japanese corporation to hang in his Tokyo office, since he felt it was representative of the America he had heard so much about before coming here. I painted the background with Prussian blue and Van Dyke brown; while the clothes are a combination of Prussian blue, burnt umber, Van Dyke brown, and burnt sienna. The flag is Prussian blue and cadmium red, and the face is burnt umber mixed with cadmium red.

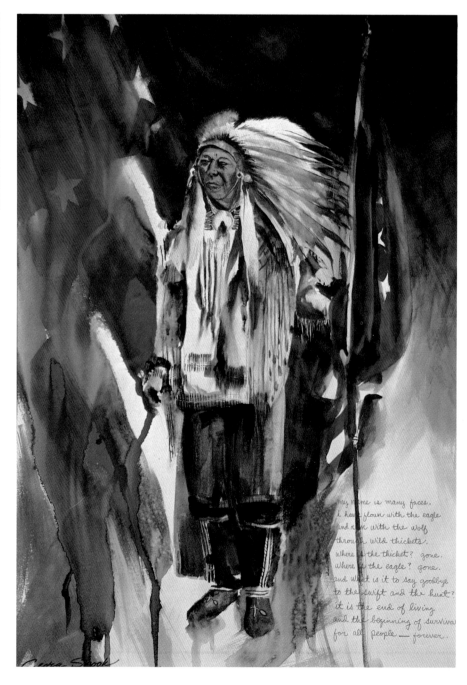

Independence Day

I saw and photographed a peg-legged man on his porch in Arkansas and that became the basis for this painting, I wanted to evoke the same mood, but I added the flag and changed the background color. The wood was underpainted with Davy's gray, then detailed in Prussian blue warmed with burnt sienna. The flag is cadmium red and Prussian blue, while the clothing is Winsor blue for the overalls and a Davy's gray wash for the shirt. The darkened doorway and shadow details are a mixture of Prussian blue and Van Dyke brown.

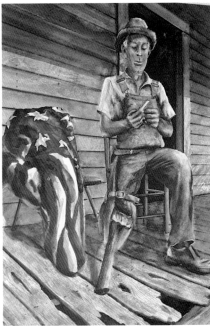

Friend of Time

Unlike *Old Man Jim*, this portrait is a character study. Here I am less concerned with getting a likeness than I am with expressing character and personality. There is a definite lack of detail here. I also changed the color of the hat and beard and eliminated the background. I used cadmium red and burnt umber for the face, burnt sienna and Prussian blue for the hat, and Prussian blue and Van Dyke brown for the shadows. The background was painted with a light wash of burnt umber and Prussian blue to kill the white.

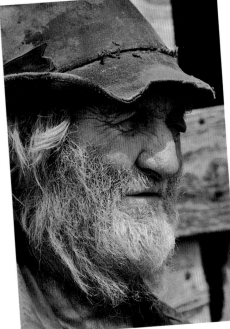

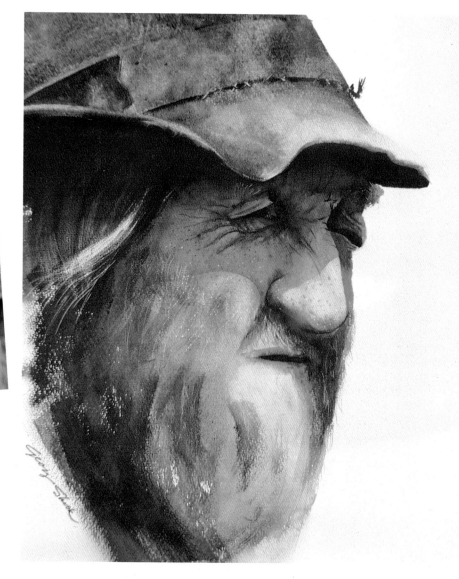

Winter Morning

Here is yet another example where I changed and reduced a scene to its simplest elements to suit my vision. As in *First Flurries*, I also eliminated a lot of detail and changed the season from summer to winter because, upon viewing the scene, I immediately envisioned a bleak winter setting and wanted to convey a cold, almost colorless wintry feeling. I used Davy's gray for the sky, burnt sienna, Prussian blue, and Van Dyke brown for the wooden structure; with a more concentrated mixture of Prussian blue and Van Dyke brown for the shadows.

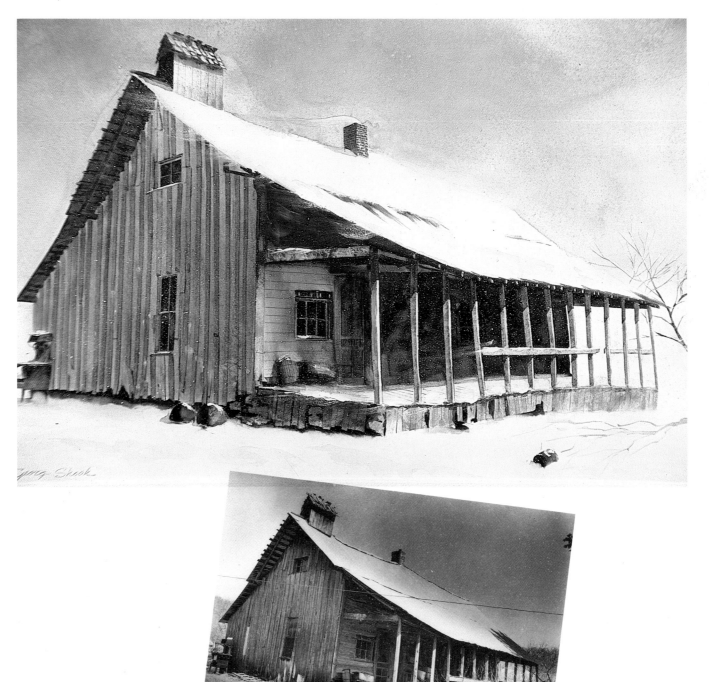

First Flurries

Here is another case where I chose to eliminate all extraneous elements from the reference photograph in order to better concentrate on the desolation of this old barn. I omitted all surrounding trees and placed the structure alone on a hill. I further heightened the sense of isolation by setting the scene in wintertime, with snow beginning to fall. For this effect I flicked opaque white onto the board with a stiff bristle brush. The sky was floated in with diluted Davy's gray, while the roof and wood detail were painted Davy's gray with burnt sienna. The shadow detail was done with Prussian blue and Van Dyke brown, while the grasses were painted olive green, burnt sienna, and ultramarine blue.

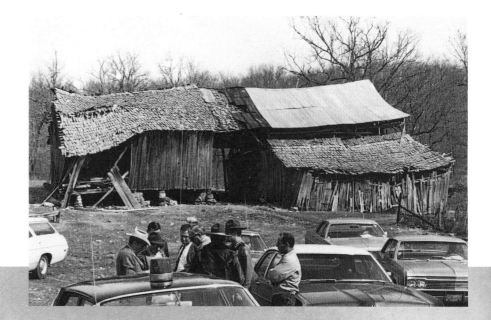

Of Toil and Labor

Here is an example of how to eliminate objects that distract from the center of interest. I wanted the barn to stand alone in its utter simplicity, so I eliminated the farm machinery and trees and placed the structure on a slightly sloping hill to give it a more dramatic effect. I used cerulean blue and Davy's gray in the sky; olive green, burnt sienna, and ultramarine blue in the grasses; Davy's gray in the wood structure—with detailing of Prussian blue and Van Dyke brown and with burnt sienna on the roof.

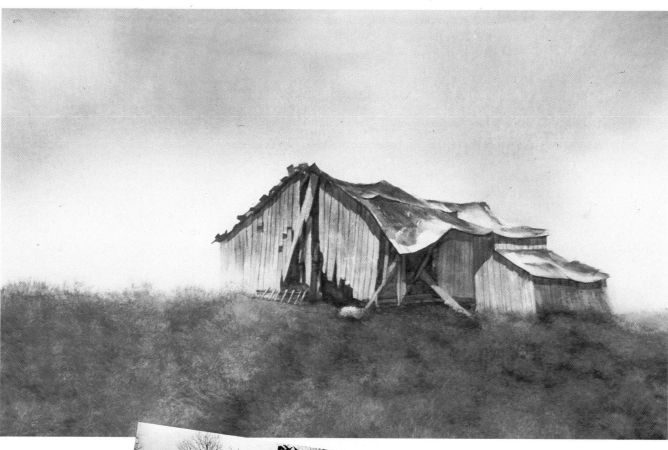

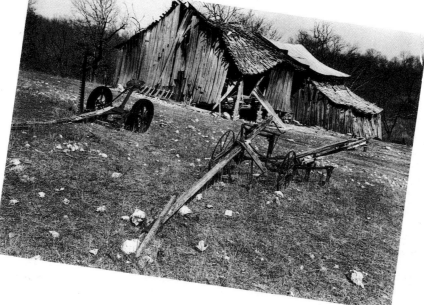

Old Man Jim

This portrait was somewhat more involved than a simple sketch or head study because I was concerned with capturing the likeness of the subject. I therefore took several reference slides to get a better sense of the mood and character of my subject. Then, working from a fairly detailed preliminary sketch, I exercised artistic license to make several changes. I felt the red cap, red brick, and red skin tones were too strong a combination for the intended mood, so I changed the color of the cap and the background, then killed some of the white by washing a delicate mixture of Davy's gray with a bit of cerulean blue over it. The skin tones were painted cadmium red and burnt umber; the hat was done with burnt umber and raw sienna; the shadow details were made with Prussian blue and Van Dyke brown; and the shirt was painted raw umber. I created wisps of white hair on the left by lifting them out of the dried wash with a thin, damp brush.

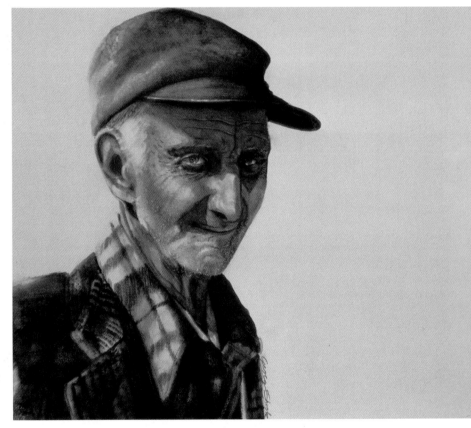

Red Lantern

Here is an example of an object painted literally but placed in an entirely different setting from the photograph. I felt that the lantern did not stand out strongly enough in the reference shot, so I redrew it, placing the lantern in the upper right area and adding a strong diagonal to accent the vertical beam on the right side of the painting. Then, to keep the eye within the composition, I created an open window at the distant end of the structure. I also changed the color temperature to contrast better against the bright red and rust of the lantern. I used Van Dyke brown and Prussian blue for a cooler interior, cadmium red on the lantern itself, with burnt sienna for the rusty metal portions. Detailing was done with a mixture of Van Dyke brown and Prussian blue, and the wooden beam is a mix of Davy's gray and burnt sienna.

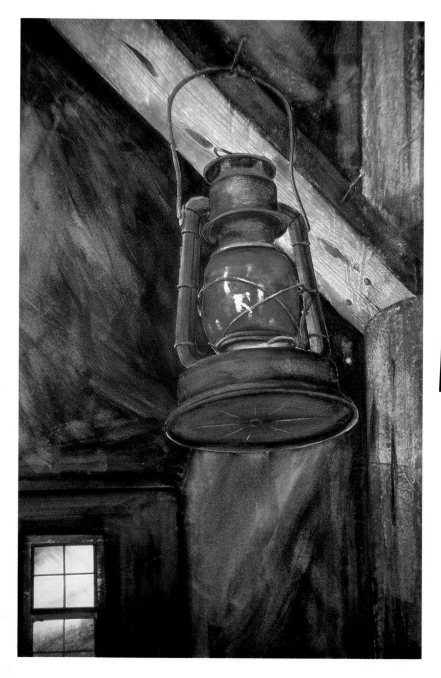

Cow Palace

I took more reference photographs than usual this time because I wanted to explore the full potential of this magnificent old barn structure. While the finished painting is a fairly literal interpretation of the third photo, I did move the structure further back into the scene and change the colors. For example, I changed the green roof to a rusty tin roof of burnt sienna, and transformed the gray siding to a bleached white siding in order to build a high-contrast painting that was warmer than the reference photograph. The sky was done in Davy's gray with a small amount of Winsor blue added. I used burnt sienna for the roof and Prussian blue plus Van Dyke brown for the shadows and structural detail. The grasses were made with a mixture of olive green and burnt sienna.

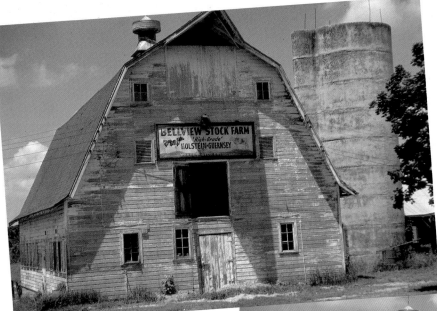

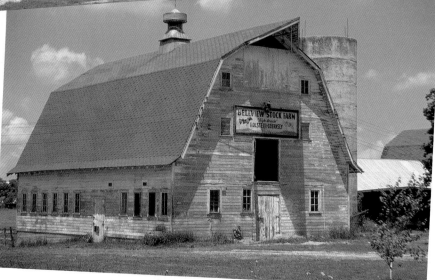

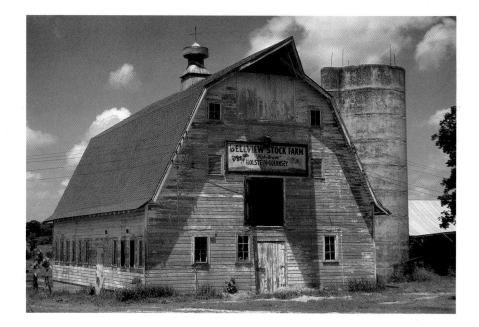

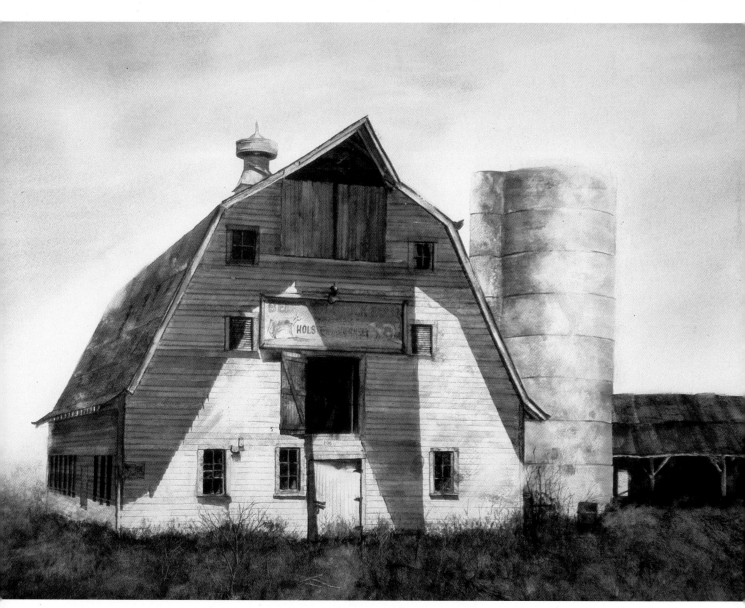

133

Cabin Light

In this old cabin interior, the photo could serve as no more than a reference for the positions of the doors and windows, since the light was too low for any available light photography. I changed the way the light played into the cabin interior and changed some details, but mainly used color mixtures to interplay the color temperatures against each other. I created the blue cloth in the box on the shelf to contrast with the warm glows of the interior wall. I used an underwash of Davy's gray, then a Prussian blue and Van Dyke brown combination for the shadow detail inside, while the outside grasses are a mixture of olive green and burnt sienna, and the sky is cerulean blue.

Shutters

In this painting I wanted to capture the mood of isolation of this window, as well as the subtle shadow and simple detail. I chose to remain extremely faithful to the photograph, with the exception of the shadow values (which I lightened) and the distracting wall across the upper left of the photograph (which I eliminated). I also elected to darken the lower window and place a reflection of tree branches there for added interest. I used Davy's gray and burnt sienna for the wall itself, with Prussian blue and Van Dyke brown for the shadow and shutter detail. The window reflections were made with Winsor blue.

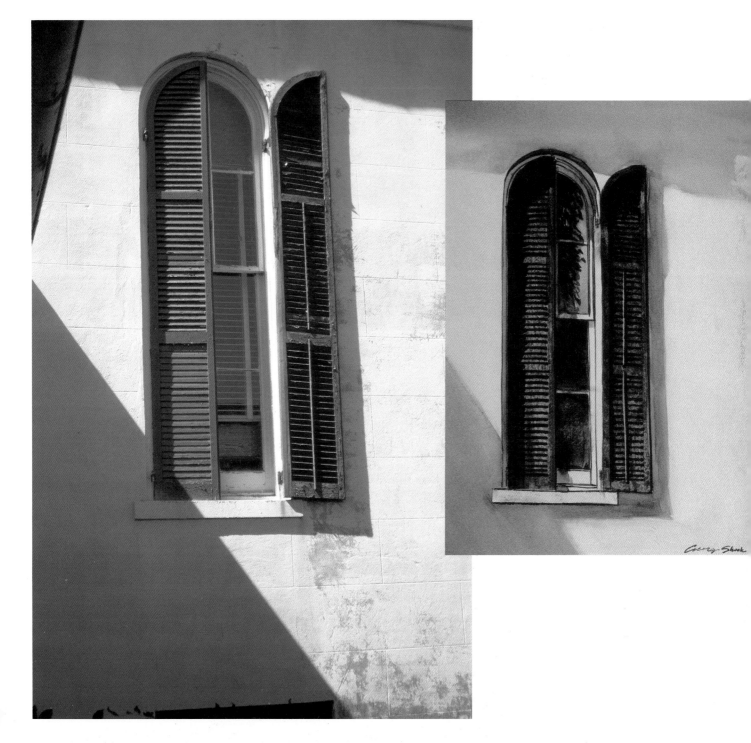

Bottle Man

This painting depicts an actual inhabitant of the Memphis streets, a man who earns a meager living collecting and selling bottles. Since he has never allowed himself to be photographed, I selected an appropriate background and shot some reference photos, one of which included a passerby. I then made a rough sketch of the bottle man and combined that with the background shots to give myself a composite with all the elements I desired. I used burnt sienna mixed with cadmium red for the background; Prussian blue, Van Dyke brown, and cadmium red for the shadow detail; Davy's gray for the streets; and cadmium red for the wagon. The box is a mixture of raw sienna and raw umber.

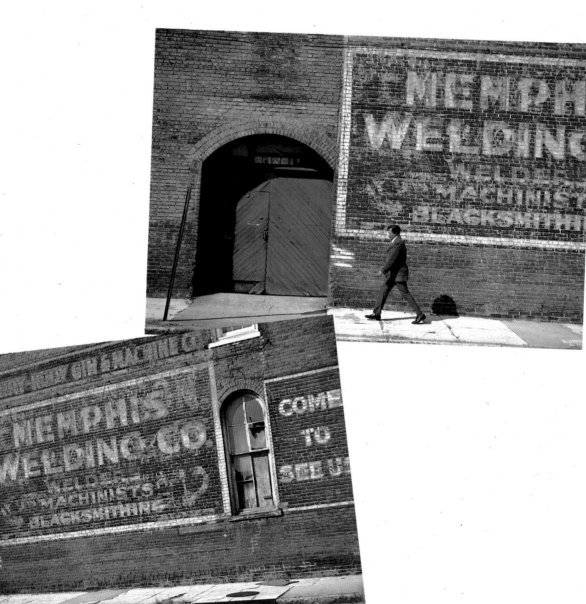

Cellar Door

I was initially fascinated with the shadows cast by the lattice work that formed an entry to the cellar door, and I created a painting with a somewhat literal interpretation of the reference photograph. I did, however, make some minor changes in the handling of the wall on the left to create a corner area and the exaggeration of the support beams in the ceiling. I feel that these minor changes created an exaggerated and more interesting perspective. I used Davy's gray for the cement wall and cellar door, and a mixture of burnt sienna and Winsor blue for the textured walls. The floor was painted Van Dyke brown, and a Prussian blue and Van Dyke brown mixture was used for the shadow details.

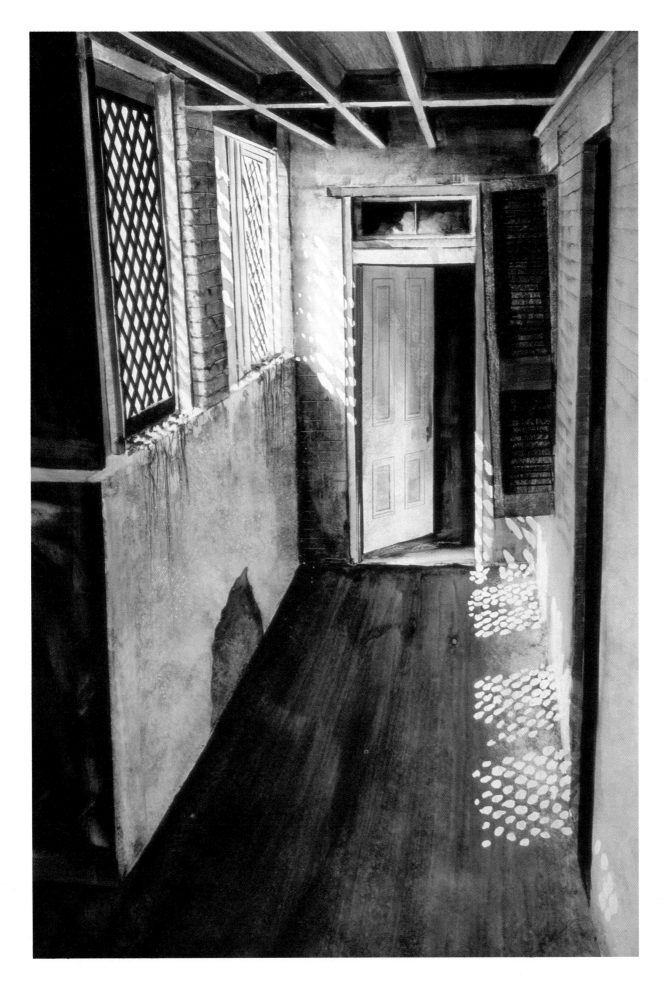

Banister

This is one of several paintings I made from a series of photographs I took of this old home near Bolivar, Tennessee. This photograph shows the entire banister across the balcony, with a window revealing a sunlit inner room. I decided to focus on the window area of the balcony and to highlight the shadows created by the lattice work and the dancing reflection of the lattice grill on the window itself. I changed the colors considerably, warming the tone to an almost mauve color because I felt that this better expressed the warmth of the sunlight against the white wood. The walls were made with a mixture of mauve and Davy's gray, and I used a mixture of burnt sienna and cerulean blue for the shadow detail. Additional detail was created with a diluted mixture of Prussian blue and Van Dyke brown.

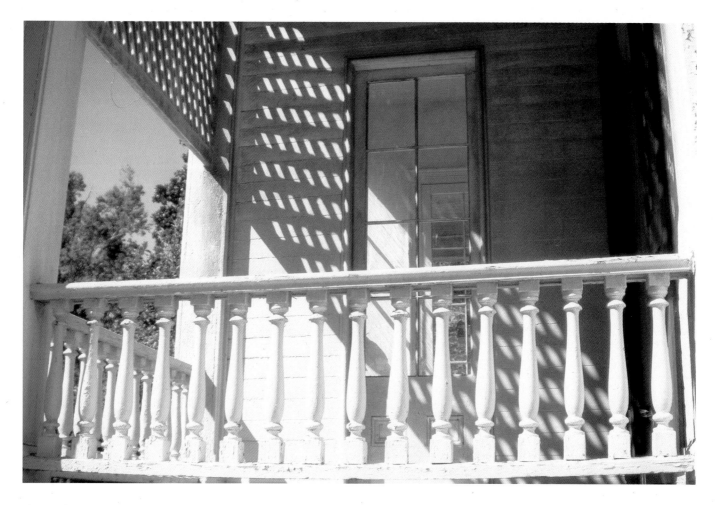

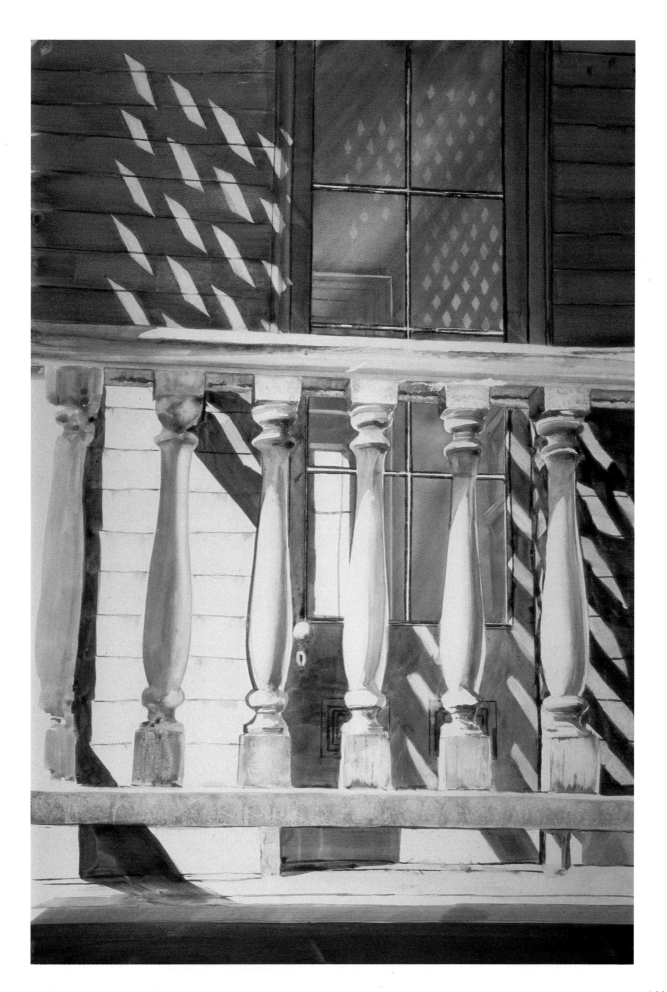

Lattice Work

In this painting I tried to lighten the color value of the reference photograph to pull a lot more light into the porch area. This creates an almost abstract pattern, with the lattice work on the left and the strong shadows cast by the sun onto the steps and back wall. Otherwise, I made few changes from the reference photograph simply because I liked the composition of the photograph well enough. I did change the color value, as I mentioned, using a mixture of Winsor blue and burnt sienna on the wood area, Prussian blue and Van Dyke brown for the shadows, Davy's gray on the steps, and olive green for the grasses.

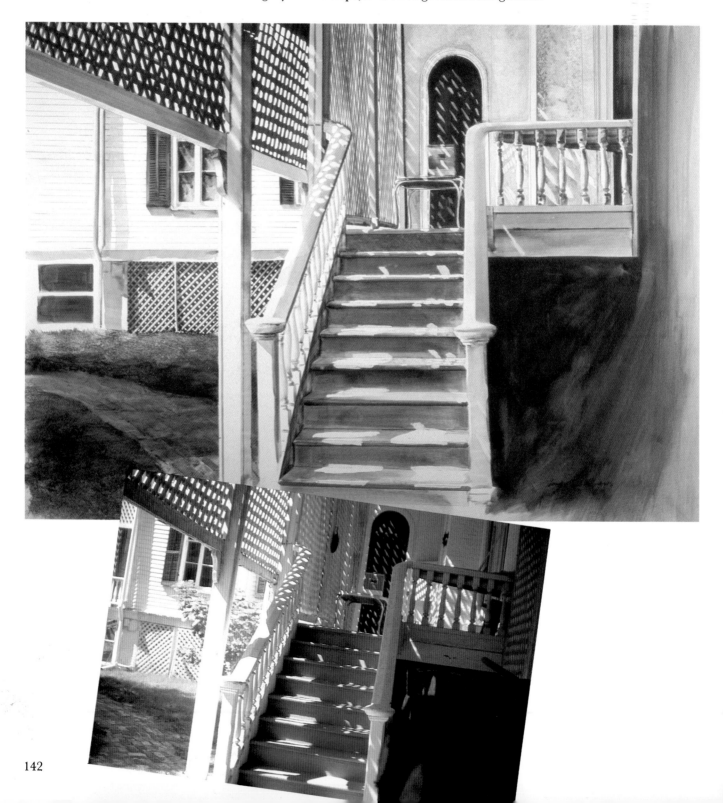

Index

Edited by Bonnie Silverstein
Designed by Jay Anning
Graphic production by Hector Campbell
Set in 11-point Baskerville